FRIEDERIKE TEBBE

HEAR GREEN THINK YELLOW

// UNDERSTANDING COLOR

jovis

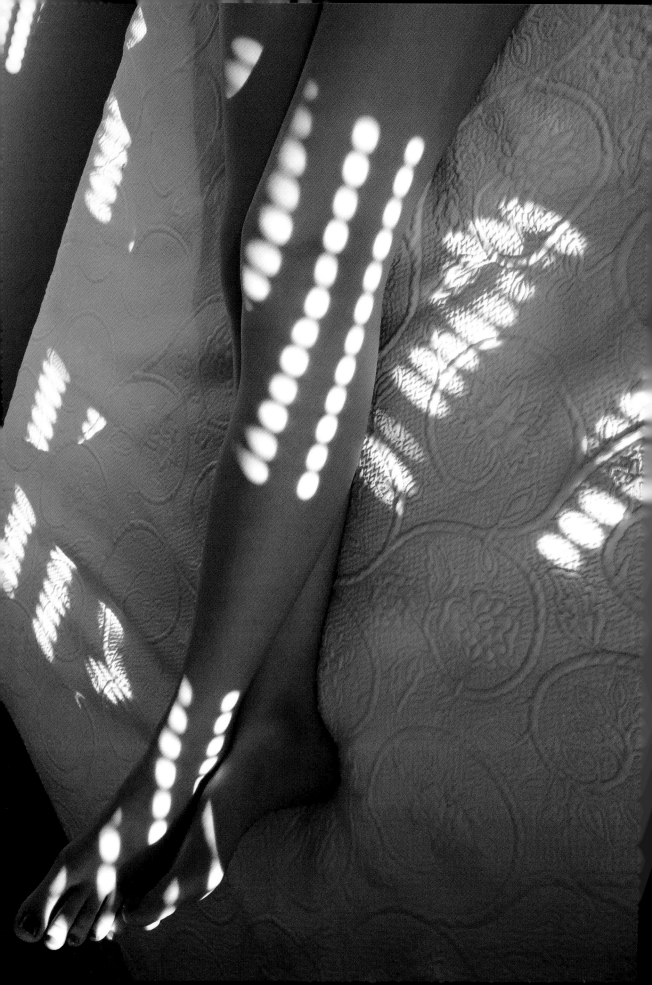

CONTENTS

REALITY BITS MATTHIAS HARDER 09

OBSERVE 24

HEARING GREEN 39

DAILY LIFE DIFFERENT FROM ART 51

THINKING YELLOW 67

COLOR DIFFERENT FROM DAILY LIFE 76

COLOR RECOLLECTION 78

COLOR IN SHAPE 81

SAMPLE AND PROJECTION 95

FINDING COLOR 114

PROJECTS 127

ACKNOWLEDGMENTS, CREDITS, AND IMPRINT 157

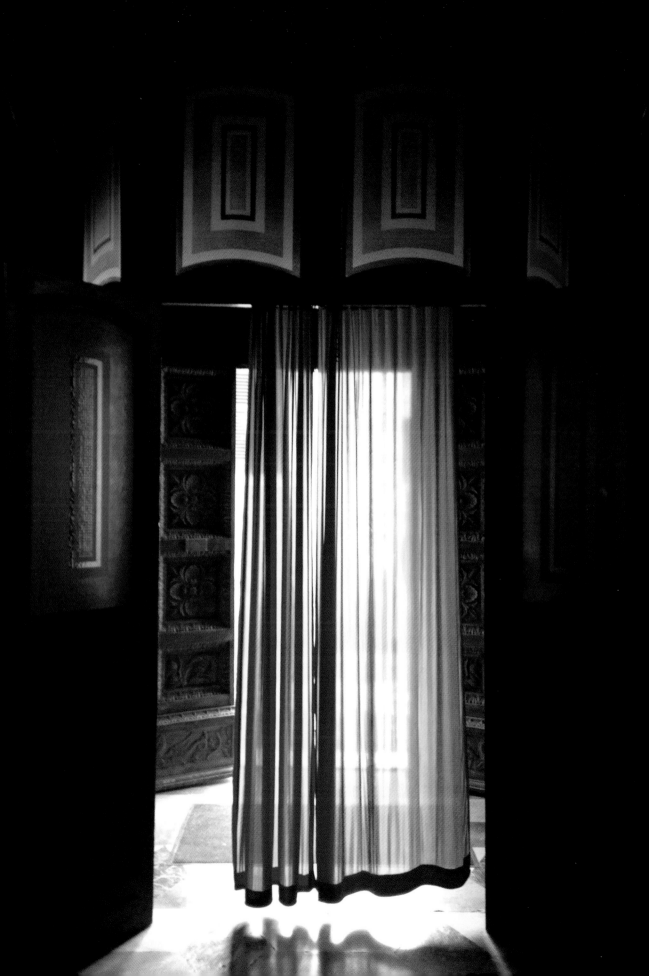

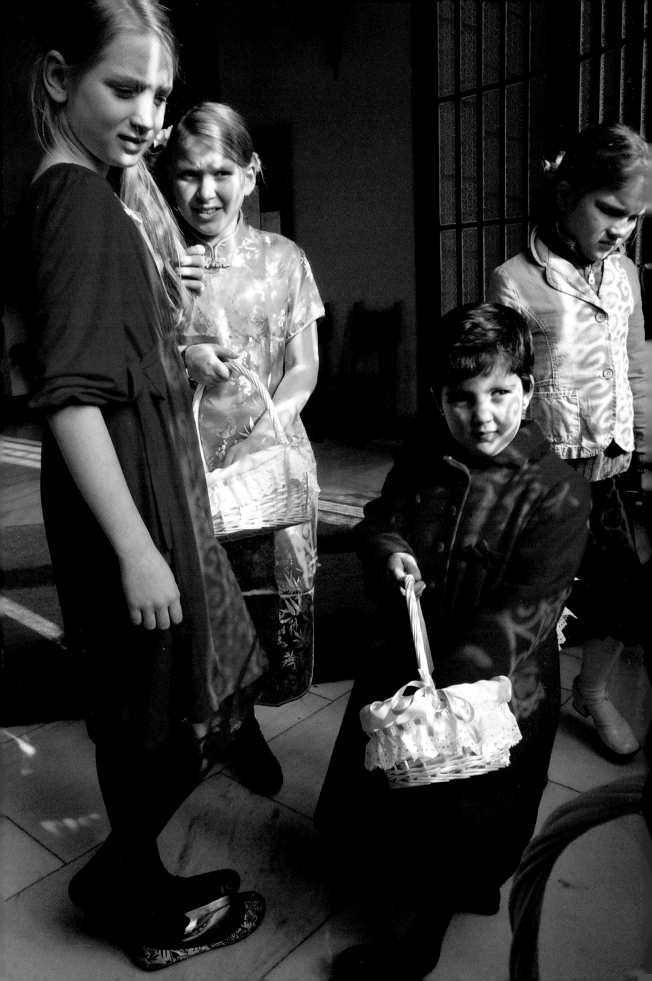

REALITY BITS

Color as a Perception Field

Matthias Harder

What is your favorite color? Everyone has a favorite color. Mine is blue—a dark ultramarine blue. Not very original, I have to admit. But this color is appropriate to me and the way I am. At least, that's how I see it. Very probably, in making this unconscious decision I am simply influenced by some experience in early childhood. I associate the color with something positive—something that I can no longer remember—and that makes it my favorite color. Colors are not just symbolic in terms of society and the history of art. They do more than create an illusory foregrounding of certain objects within a painting (while causing others to recede). They also evoke and influence feelings and moods. Additionally, we respond to them in very individual ways.

But if we ignore for a moment all the things that are generally said about color, all the things we associate with it, all its apparent physical and psychological effects, what does that leave us with? Nothing but an RAL number, Goethe's theory of colors, and perhaps a diffuse emotional impression. This state of affairs is intolerable. Fortunately, we, as human beings—unlike animals, whose eyes generally have far fewer color receptors—are able to distinguish fine gradations of color tone. We are also fortunate to have color experts, artists such as Friederike Tebbe. She can open our eyes to the smallest nuances of color (including the exceptionally rich palette offered by the various different shades of grey), but also to the countless possibilities that exist for subtly combining (or colliding) them. The nuance one sees in Tebbe's color spaces are rare indeed. Outside of the classical medium of painting, few creative individuals devote their efforts entirely to color. Friederike Tebbe is one such individual. When one looks at her previous

projects—both free and applied—one sees that she is also one of the most interesting people working in this field in Germany. Her work is entirely based on an overarching system: she makes additions to a small but significant part of new designs for interiors and exteriors. It is not just that she drenches individual walls or a whole series of rooms, information counters or staircase panelling in color.

Like many others, I am also fascinated by her photographs. Seen in the context of Tebbe's other work, these photographic images can be understood first and foremost as snippets of reality, as sketches used to check her own ideas, or as a *visual diary*; they give an idea of the clear, reduced color design of her commissioned works while being, at the same time, entirely autonomous. For this reason, I consider an examination focusing on this complex of artworks to be very worthwhile, and long overdue. We are confronted with apparent snapshots that, when we look at them more closely, are revealed as rapid but very precise observations of Tebbe's environment; she is constantly on the lookout for interesting color codes, subsequently dissecting her own photographs systematically in order to extract them. Ultimately, she combines the sights she has encountered during walks, car trips, and holiday travels, converting them into photographic images to create a precise color analysis. In these photographs, we see road markings or garbage containers, an architectural façade, the floor of a church, sometimes a woman's hand or ink dissolving in water. As is always the case with photography, light plays a very important role, as does surface materiality and specific spatial qualities, but the central factor is the localized coloring of the objects, whose form and function is largely irrelevant. This is an interesting and unconventional approach to visualization. Thus, in the medium of photography, as elsewhere, Friederike Tebbe presents and defines color details, color surfaces, and tonal qualities as perception fields, devoid of any concept of decoration. This has an effect that is quite independent of any individual's favorite color—and surely not only upon myself and on my reception process as an art historian.

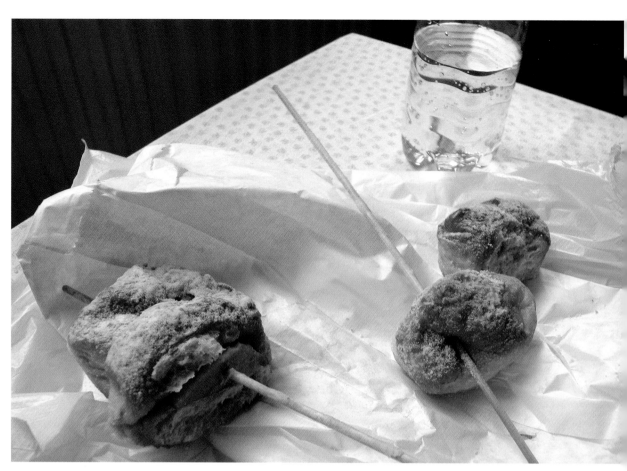

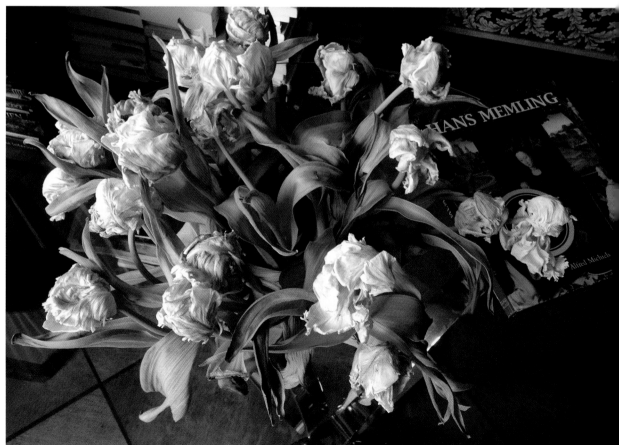

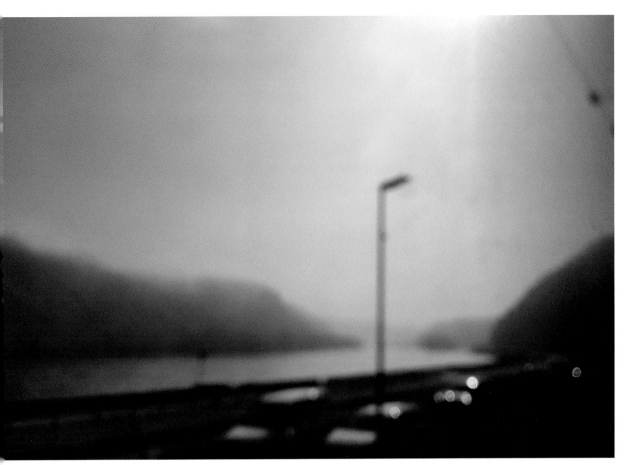

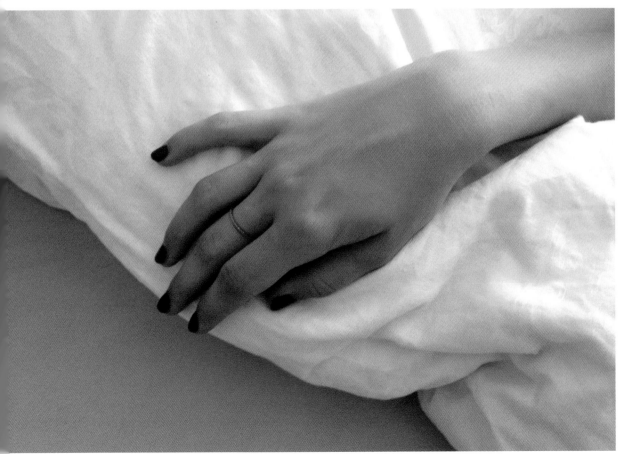

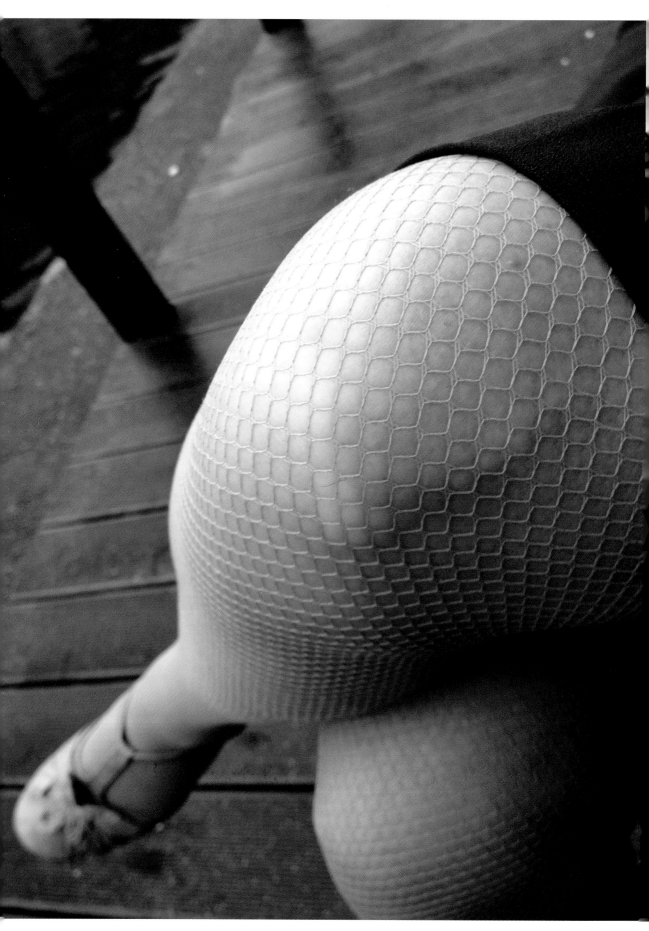

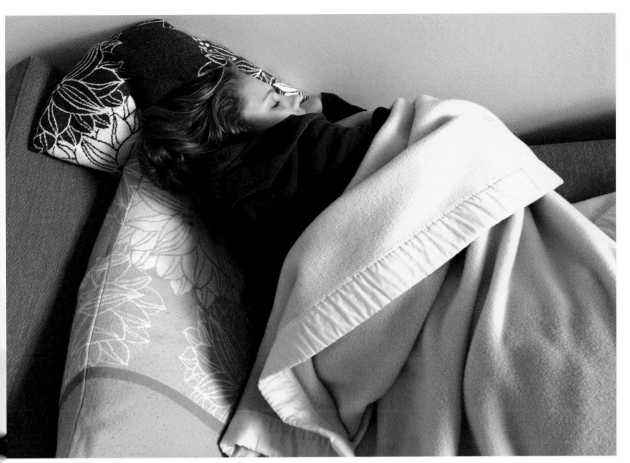

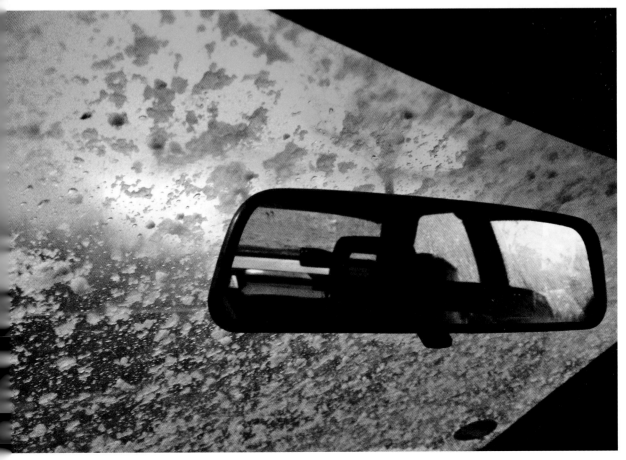

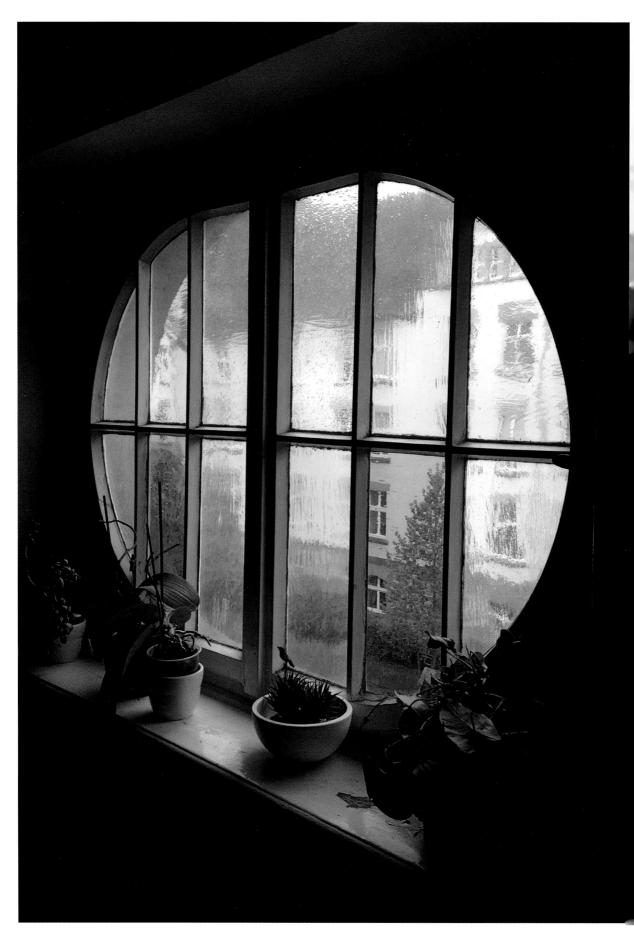

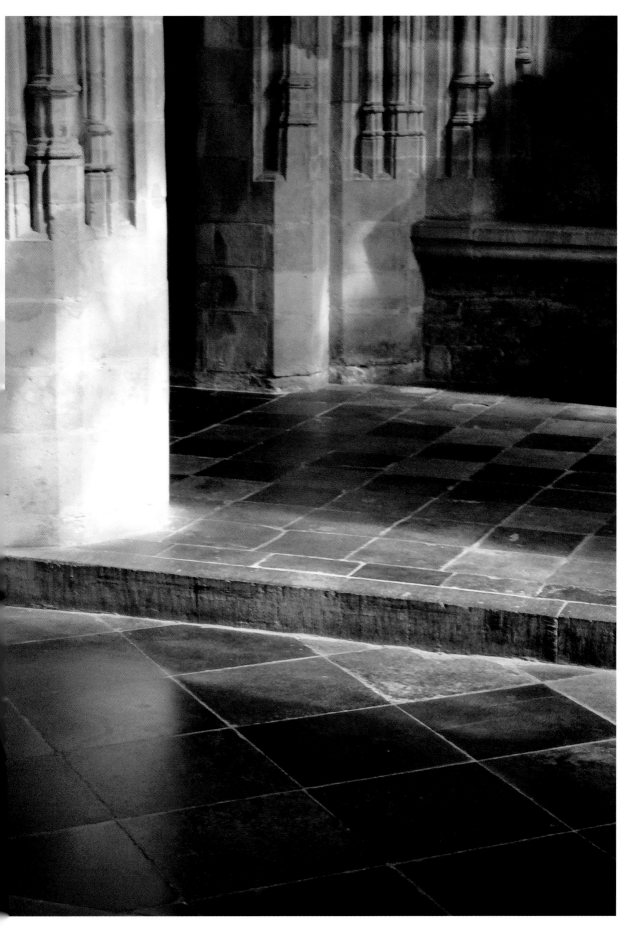

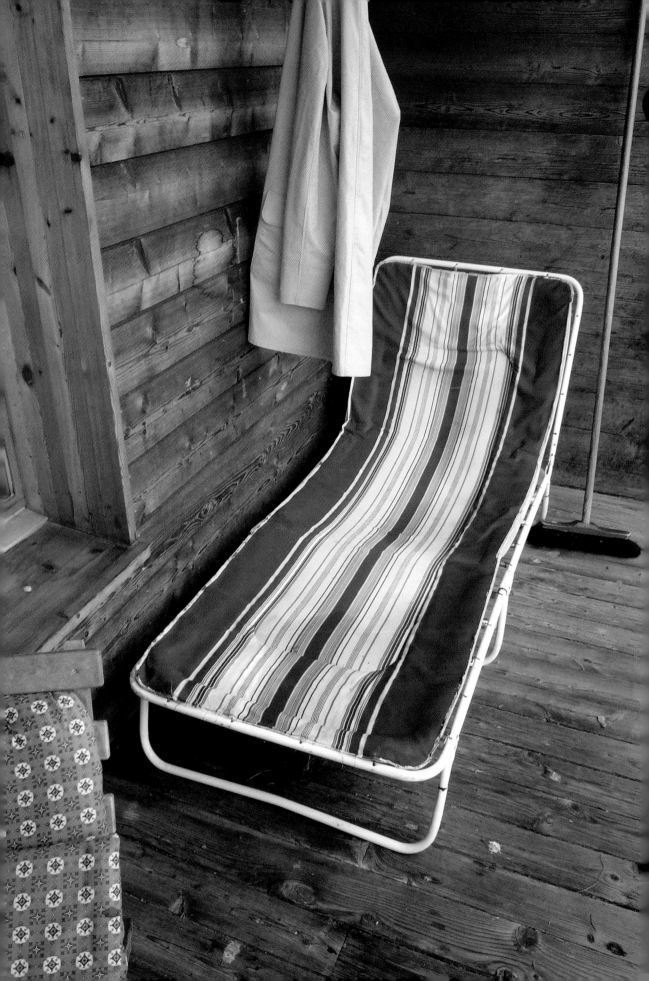

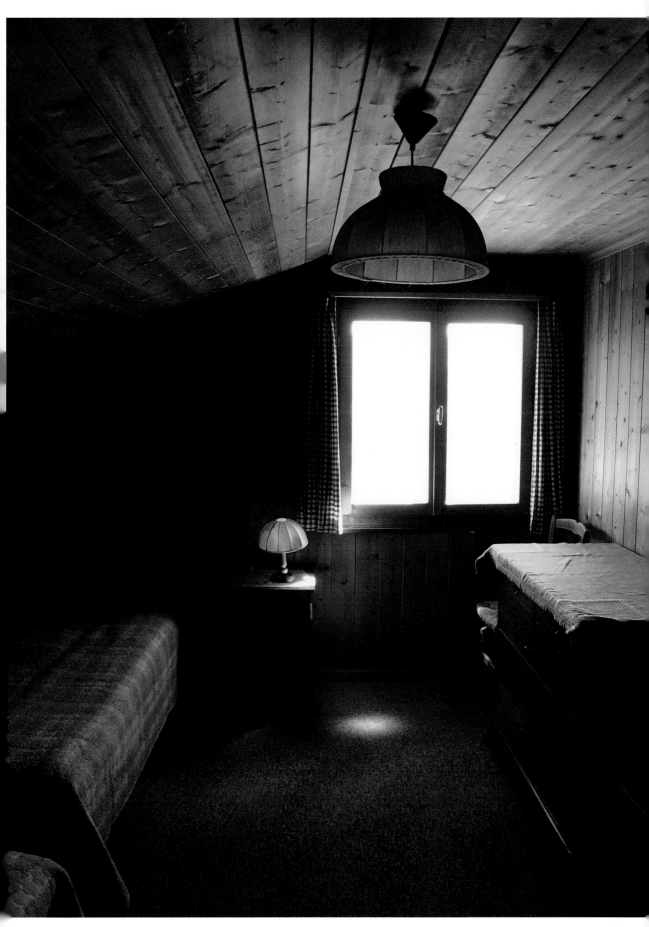

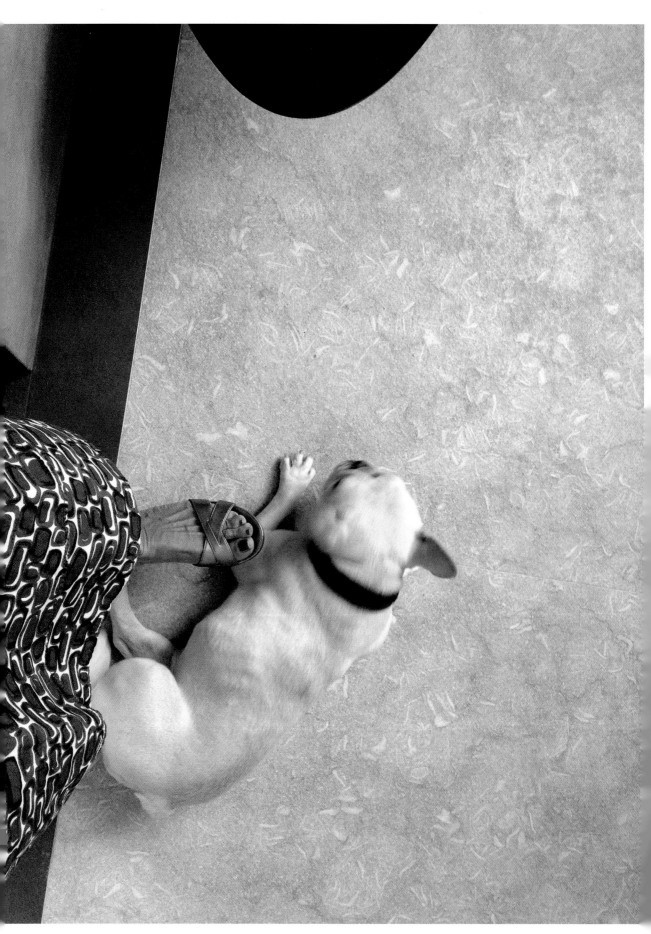

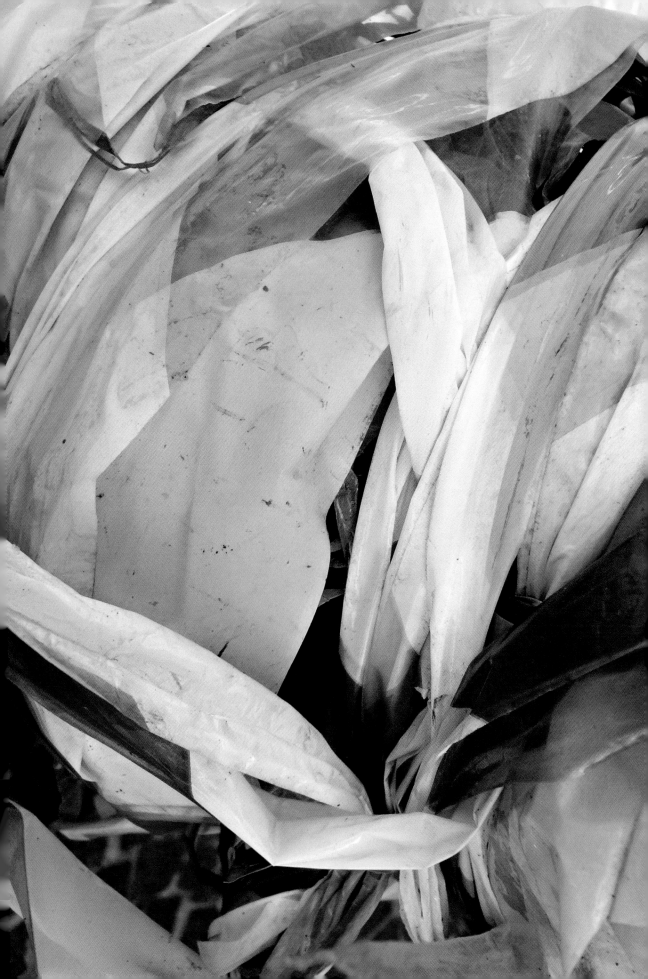

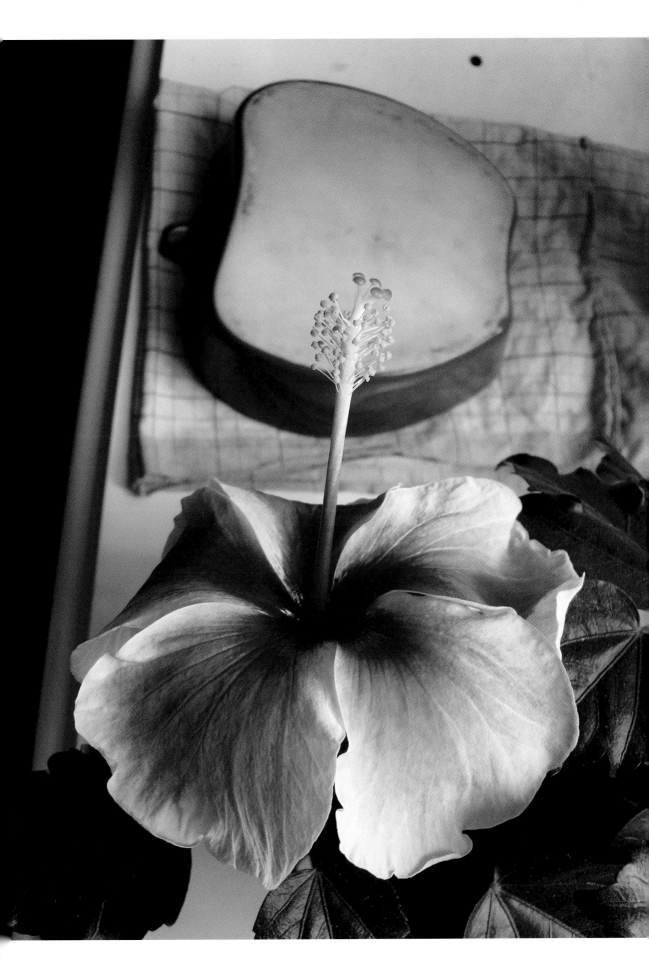

OBSERVE

"It's not what you look at that matters,
it's what you see." Henry David Thoreau

Our world is a colorful one. Colors create order, presentation, and orienta-
tion. We perceive color before we read outline. Our sight can distinguish up to
eleven million color nuances—while our vocabulary offers 5,000 words with
which to describe these nuances. In our conscious awareness, this wealth of
sensory impressions shrinks to just eight color tones that our memories are
able to retain with some degree of accuracy. We love colors. Almost all of us
have a favorite color, and one that we cannot stand. Like it or not, color di-
rects our attention. Color sells. And yet we don't really take color seriously.
Unlike "scratchy" or "loud," "blue" is harmless—or initially appears to be.
It is therefore not surprising that color is often the last thing considered in
the design processes. Whether a pair of trousers or a car is red or blue is a
question that pales in significance in comparison to "really relevant" factors
such as the fit of the clothing or the performance of the machine. The color
of an item does not initially appear to be especially significant, unless the
addition is to your wardrobe, it's a new car purchase, or you're redesigning
a living space—then our relationship regarding color changes dramatically.
Suddenly, something normally secondary and taken for granted becomes
the cause of mystification, if not despair: how do the items in my wardrobe
combine? Why doesn't the automobile industry's palette of on-trend colors
include my favorite color? And which shade of wall paint goes best with my
sofa? It is then that we find ourselves lively expressing definite preferences,
preconceptions, and reservations. And yet most of the time we don't know
where they have come from and how reasoned they may be. It is more of a gut
feeling. Most of us have little experience in dealing with color—in spite or
because it surrounds us in such vast quantities—and have little insight into
the complex interactions that affect its impact on us. The depth of such gut

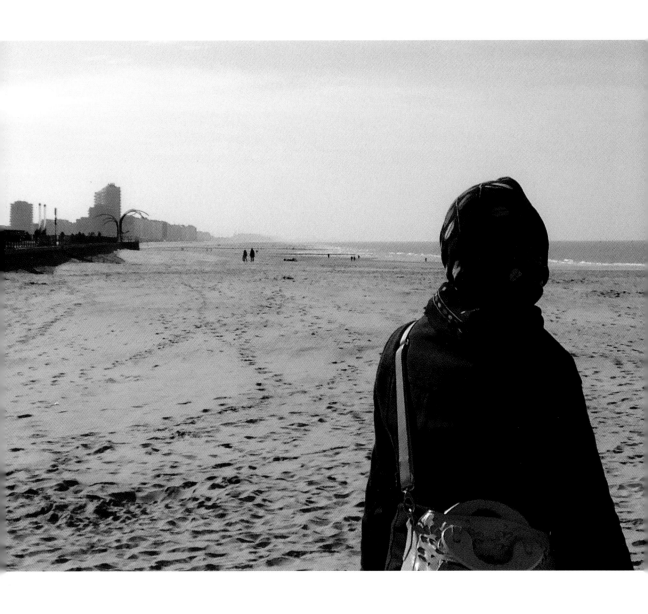

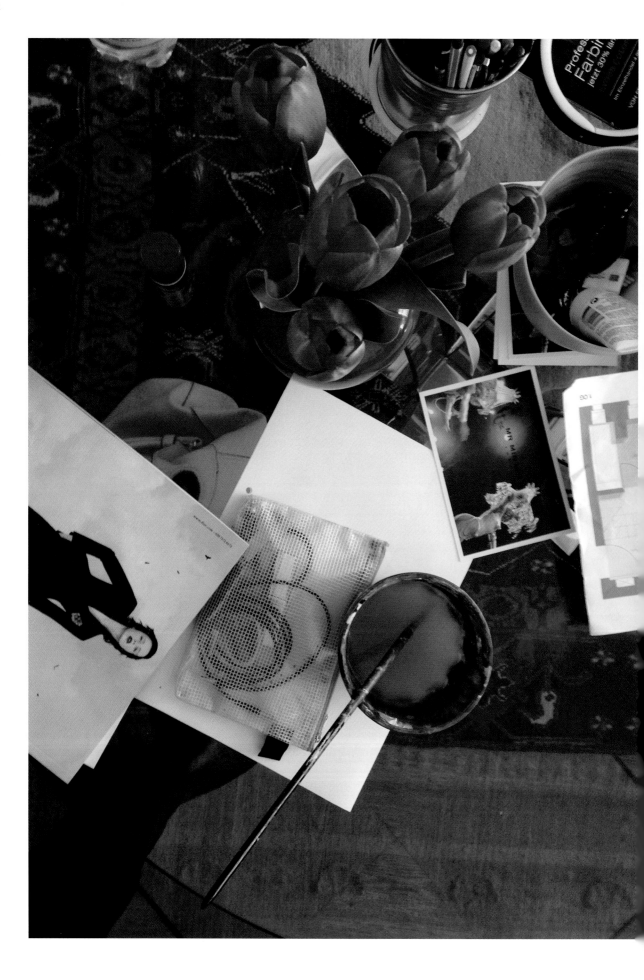

feelings paired with irresoluteness when having to choose the "right" color from the vast spectrum on offer, however, makes one thing clear, color is anything but a harmless matter.

Like smell and taste, color strongly influences our emotions. It directs our gaze—color sells. And yet, as a medium that constantly changes, it is very difficult to grasp. Close examination is the first precondition for a confident understanding of the interactions of color. But how does this process—seeing, recognizing, understanding, and judging—function? Amid the sea of colors that surround us every day, so seemingly random and diverse, jumbled-together and confusing, alluring and incomprehensible, how can we create an overview, a tool? How can we refine our visual awareness, and cultivate our ability to discriminate?

Start by taking a closer look at your surroundings and follow your gaze. Just by examining your observation alone you will learn a lot about color and its effects. This book's intention is not to give advice about good taste in color design or to be design manual. You will find no recipes for when and how to use the color red and no statements as to how what hue of yellow may support cogitation.

Instead, this book wants to stimulate your senses to understand the interaction of color. To better understand how it affects you and your decisions. To help you to discover and develop your color sensitivity—to introduce the world of color.

Observe what and how you see. Recognize what, you think, you are seeing. Create a kind of inner color scrapbook in which you collect your impressions and insights. Photograph, make paper cuttings, use a brush; if you don't have the time, just look around attentively—try to memorize. Try to see things without attaching meaning or placing value: this is, in itself, more difficult than one might think; it requires a certain distance. But once achieved, it may change the way you look at things. A change of viewpoint and perspective will broaden your visual experience. Vary your line of sight, look at your environment from above, below—try to see your surrounding with the eyes of an extraterrestrial. Imagine that you are seeing things for the first time —focus on shape and color.

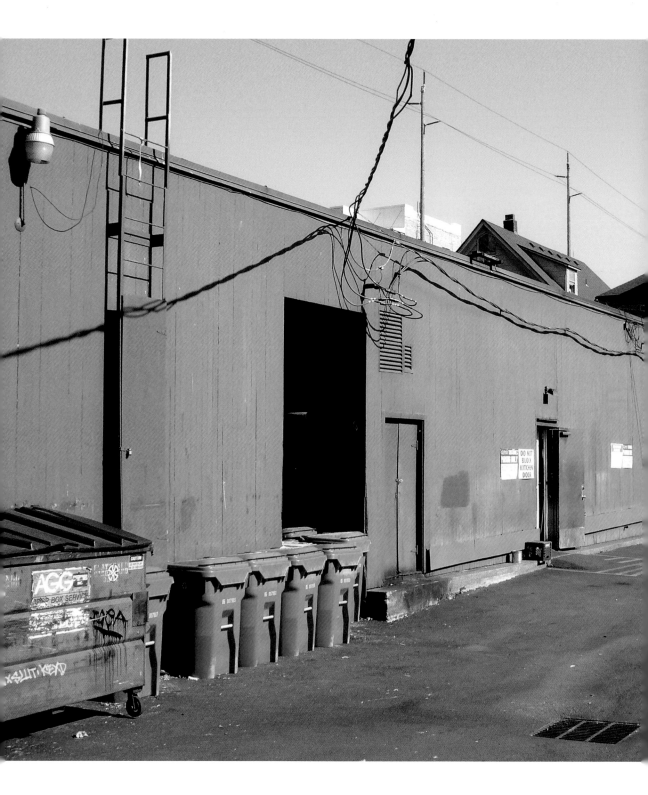

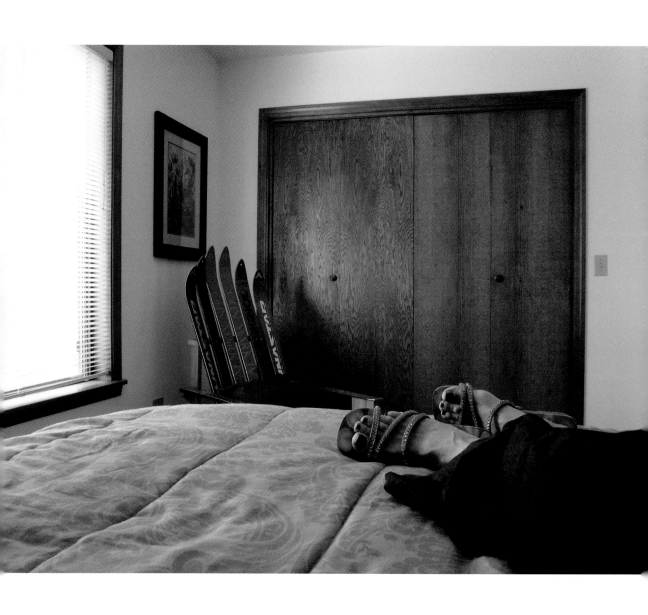

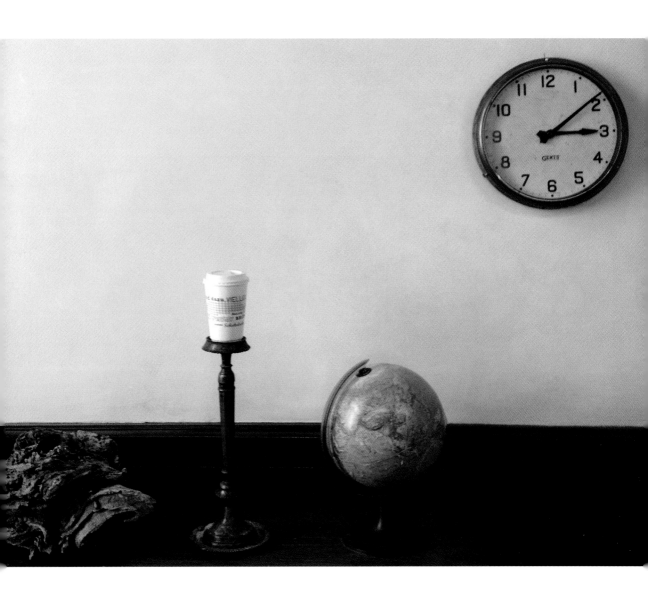

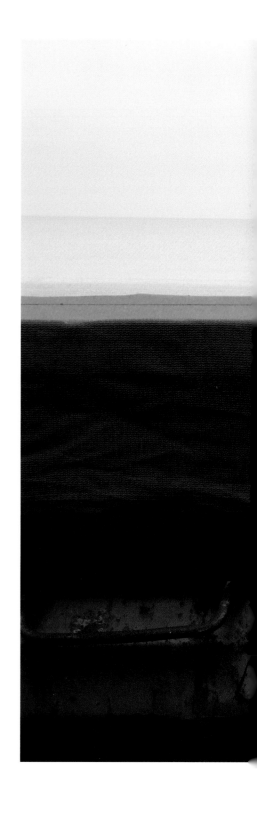

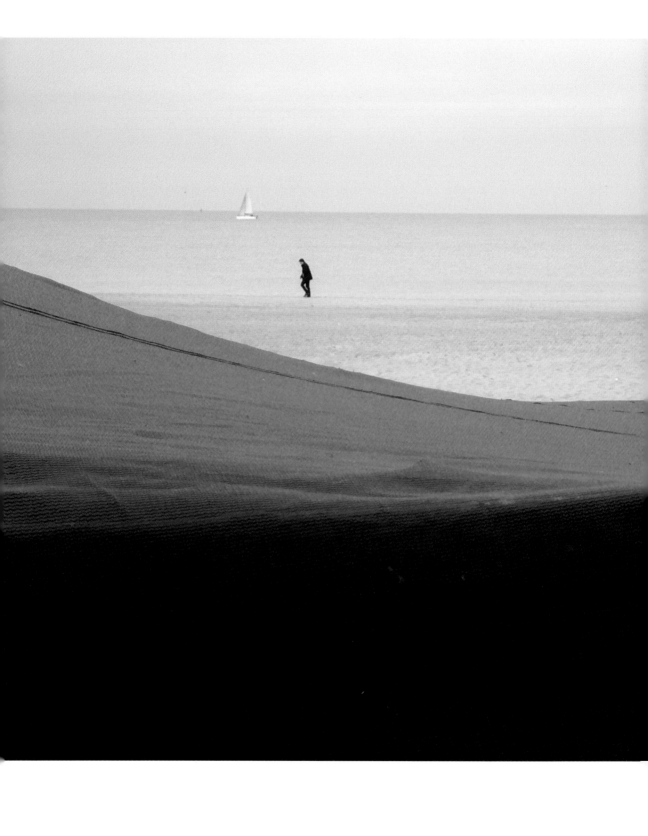

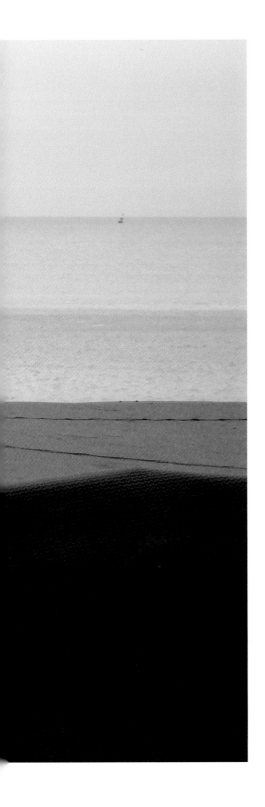

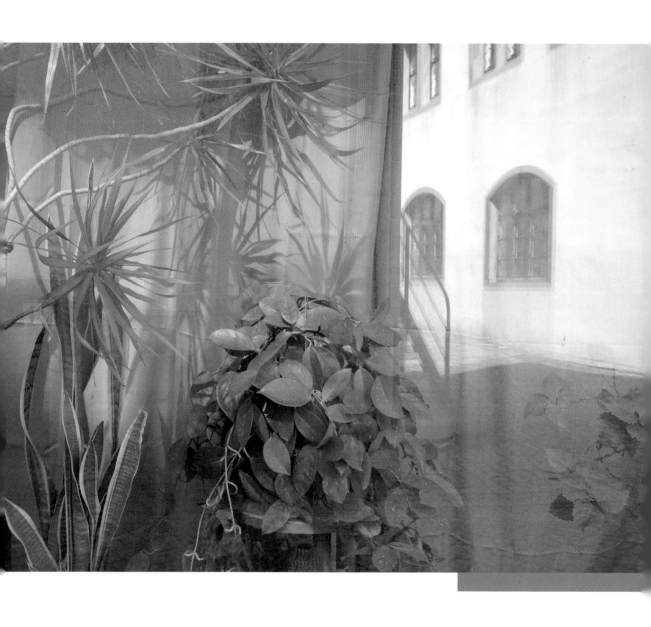

THE COLOUR OF ELEGANCE

NEW YORK · BEVERLY HILLS · CHICAGO · LAS VEGAS · BOSTON · SAN FRANCISCO · HONOLULU
PALM BEACH · PHOENIX · COSTA MESA · BAL HARBOUR · MANHASSET · DALLAS · PALM DESERT · SEATTLE
www.escada.com

orange

HEARING
GREEN

frieze

CONTEMPORARY

GEOFFREY FARMER

Sculptors Discuss Sculpture
Social Spaces: CAN ALTAY talks to
DAN GRAHAM
Project: MOYRA DAVEY

No. 03 Prim Pink

Being thrown into a 1980s jail cell with every single surface painted pink may have felt like a government-funded acid trip, but the results were unarguable. From prisoners to military personnel, the outcome was the same. Just fifteen minutes spent surrounded by this color was enough to suppress all angry, antagonistic, and anxiety-ridden behavior. After six minutes all traces of violent behavior were gone, regardless of how aggressive they'd been.

vollebak.com, the science of baker miller pink

In a liquid, turbidity in the form of colloidal matter or suspended particulates can scatter the light transmitted through the liquid in a way that alters the observed color. If a color measurement is made without first removing the colloidal or suspended sources of turbidity, the resulting measurement is known as apparent color. True color is the measurement made following the removal of colloidal or suspended sources of turbidity. The color of liquids is also pH dependent, increasing in color with increased pH, which may require pH measurement or buffering.

www.asaanalytics.com/color-analysis

No. 17 Elektromauve

No. 012 Packman

The differentiation between warm and cold colors is pure custom and adapts with each era and the correlating changes in society. For example, during the middle ages blue was commonly perceived as a warm color.

Michel Pastoreau: Blue. The History of a Color.

Color therapy relies on earthy brown tones to treat vertigo, as it conveys a certain feeling of comfort and security. More recently, though, brown has found its way into the fashion industry where it now often appears as a lavish accent.

From the German women's magazine "jolie"

No. 101 Römisch braun

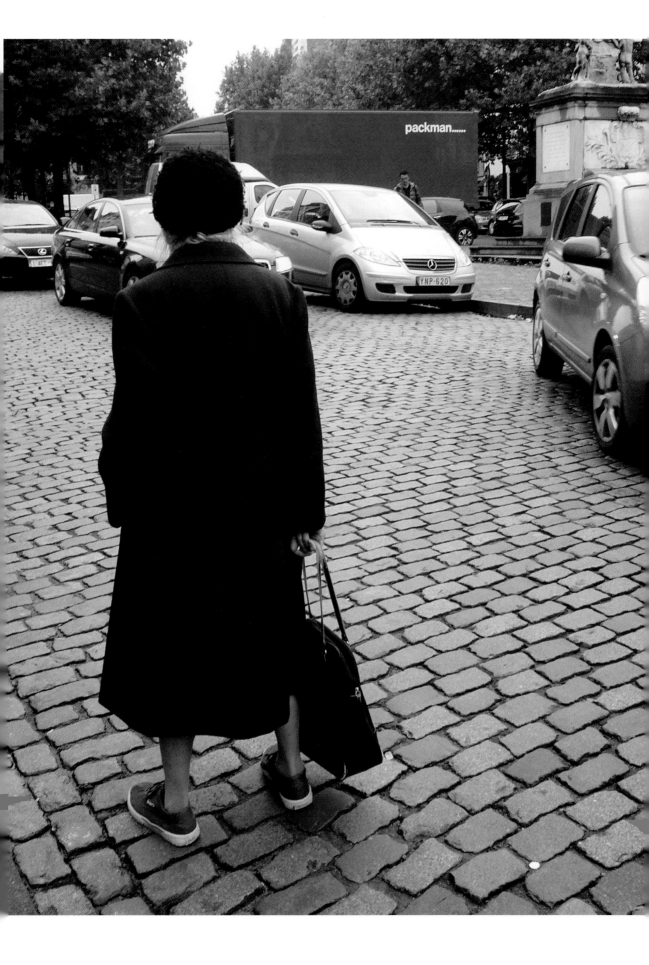

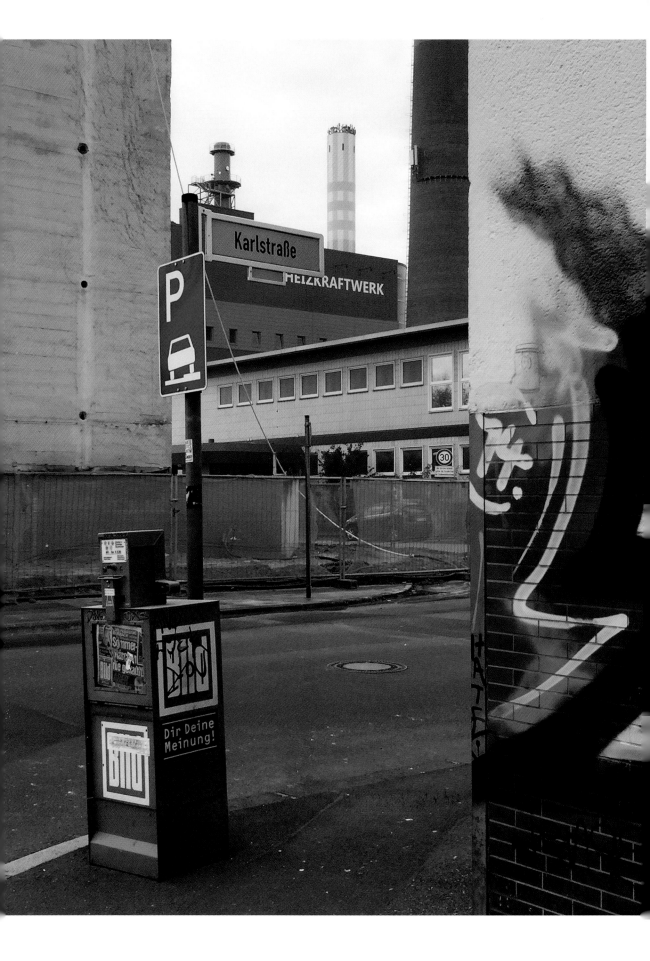

No. 09 Blackbird

The world's darkest black, Vantablack, is categorized as a Superblack, consisting of an ultra-thin layer of nano carbon cylinders, each 10,000x thinner than a human hair. In this structure, the carbon is stacked so closely, it absorbs almost all light. Only 0.035% of light particles and waves are reflected, barely recognizable to the human eye. A Vantablack coated item appears as no more than a simple silhouette to the eye. Supposedly an internationally renowned artist already purchased the exclusive rights for any artwork relying on Vantablack, much to the upset of other artists.

There is an old prescription among painters for seeing more life and greater richness in the colours of a landscape, and that is to stand with your back to the landscape, your legs wide apart and bend forward so far as to be able to see between them. The intensified feeling for colour is supposed to be connected with the greater quantity of blood running to the head. Vaughan Cornish suggests that lying on one's side would produce the same effect. He ascribes this to the fact that the well-known over-estimation of vertical distances is neutralised (§ 110), so that the tints apparently show steeper gradients. The question is whether this applies also to the much stronger effect while bending.

Marcel Minnaert: The Nature of Light and Colour in the Open Air

No. 27 True Beauty

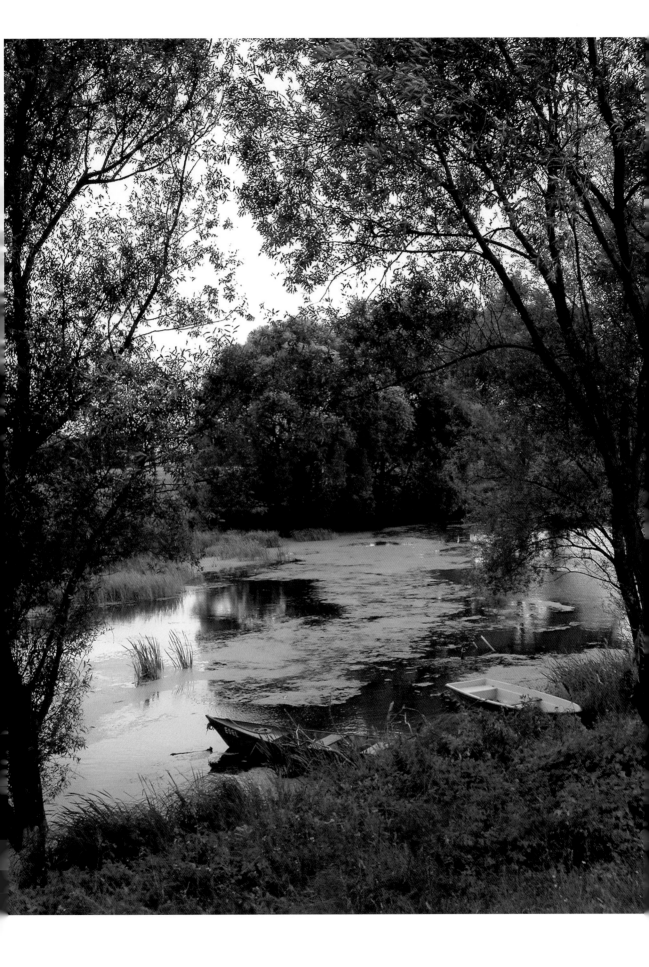

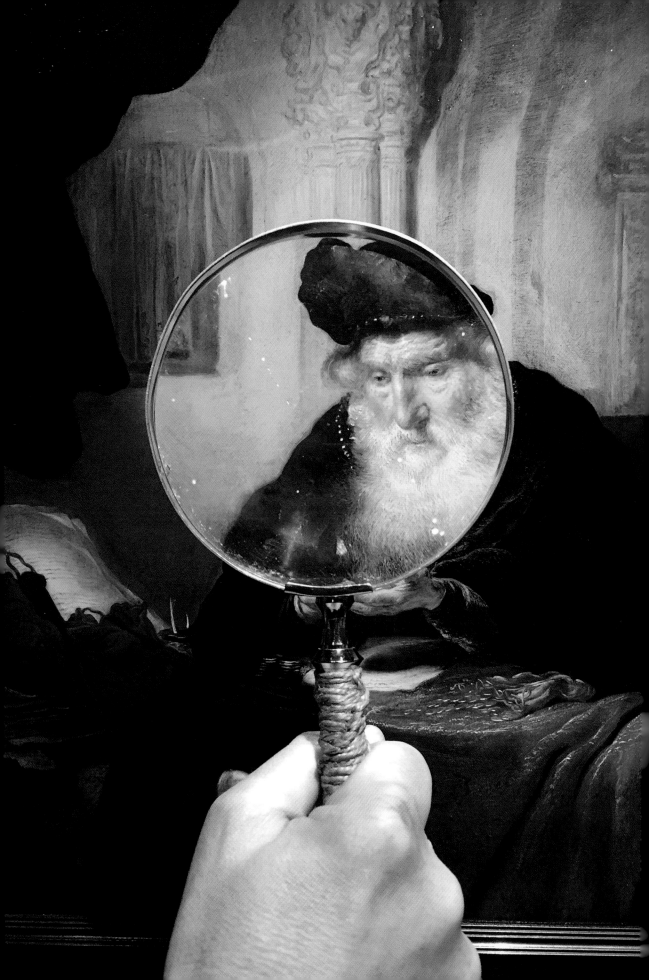

DAILY LIFE DIFFERENT FROM ART

Aside from the immediate conditions such as surroundings and light, our sense of color—how it affects us—also depends upon so-called mediated and veritable factors: cultural context, group-specific aspects, our individual disposition, it is up to how we feel on a particular day.

The way we look at color, and how we interpret what we see, are questions that extend into the fields of psychology and communication. The answers to these questions tell us a lot about our habits of seeing and our focus of attention. And that again tells us about our individual visual perceptual architecture. How selectively do we perceive what? At what times? What draws our attention and what does not affect us at all? What do we intend to see, what do we actually see, and what do we simply overlook? All our thoughts, preferences, dislikes, prejudices, etc. stem from our well of internal images. By investigating this source of images, you can trace the outlines of your architecture of perception. By which you can follow your individual visual paths and explore corresponding visual compartments by observing your own modes of seeing.

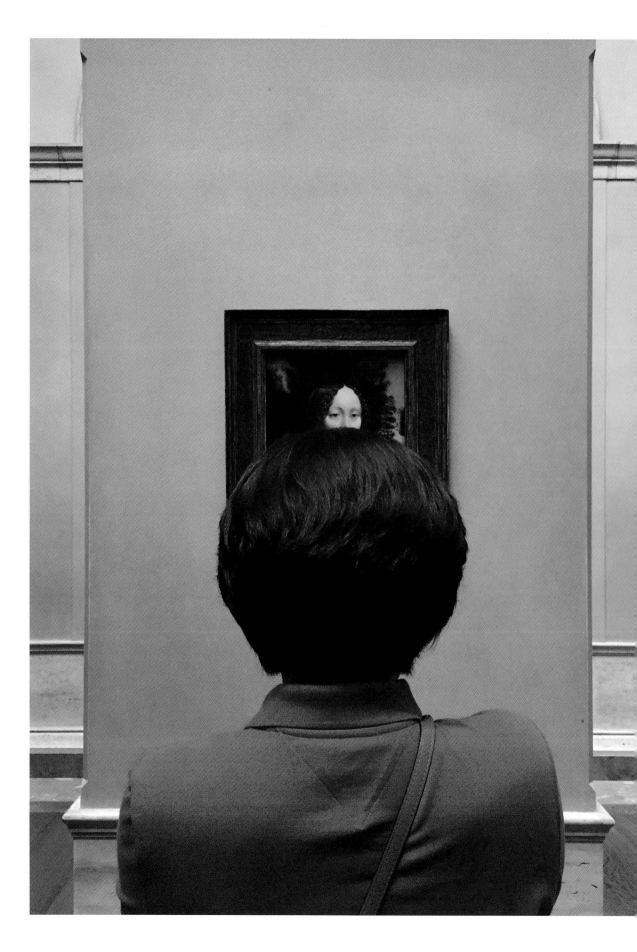

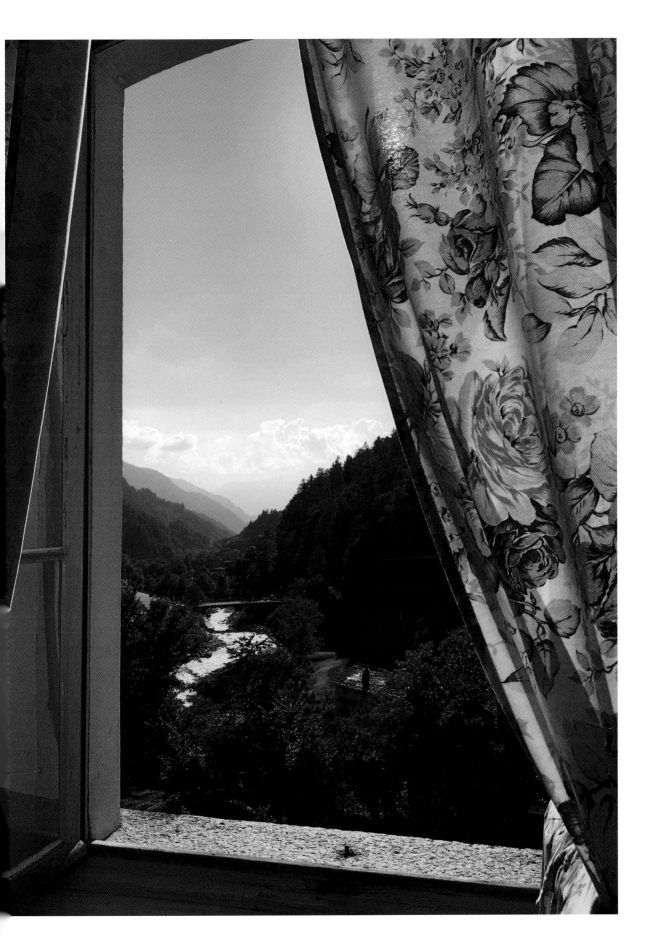

Can you look and listen precisely at the same time?

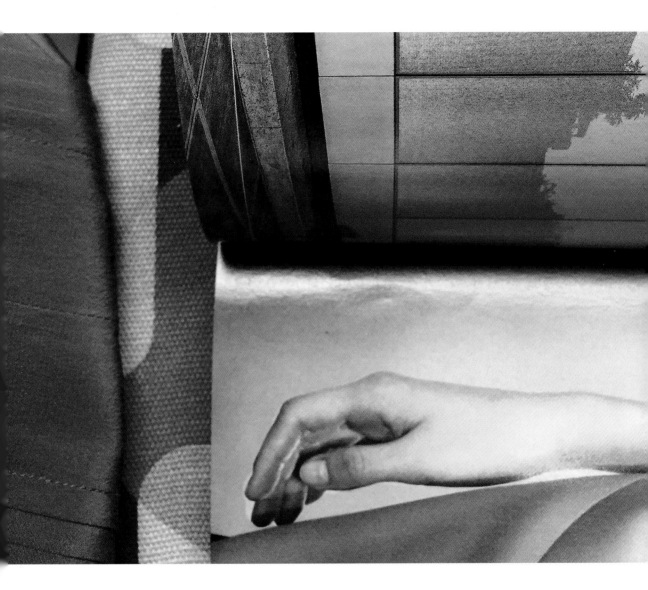

Do you look at things differently while sitting, rather than standing up?

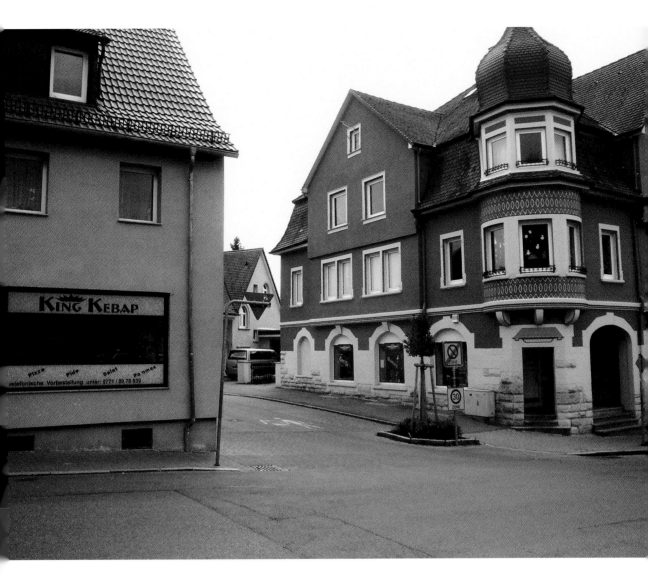

Do you tend to look sideways, or rather straight ahead?

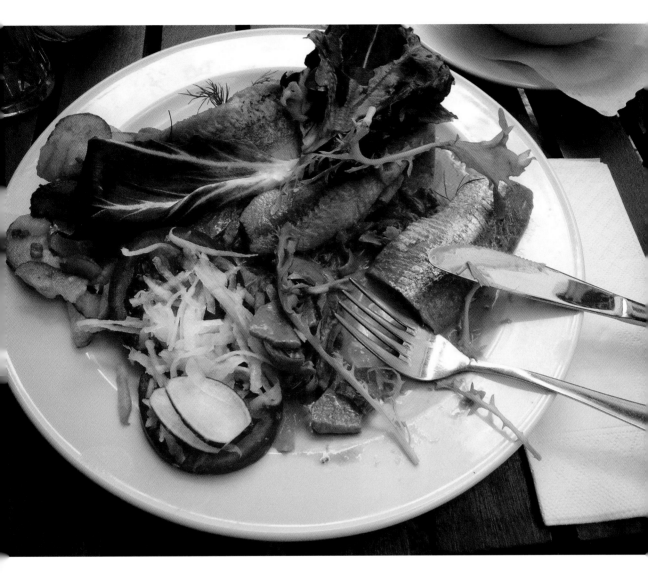

Do you pay attention to the coloring of your food?

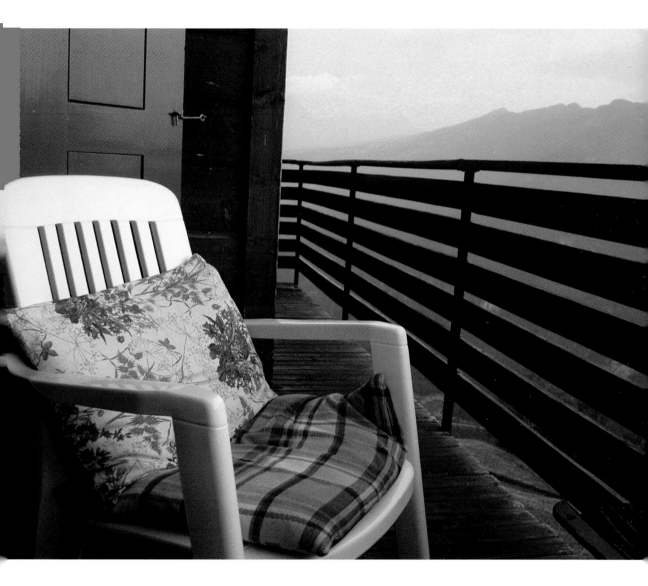

Are you aware of what it looks like behind you at this very moment?

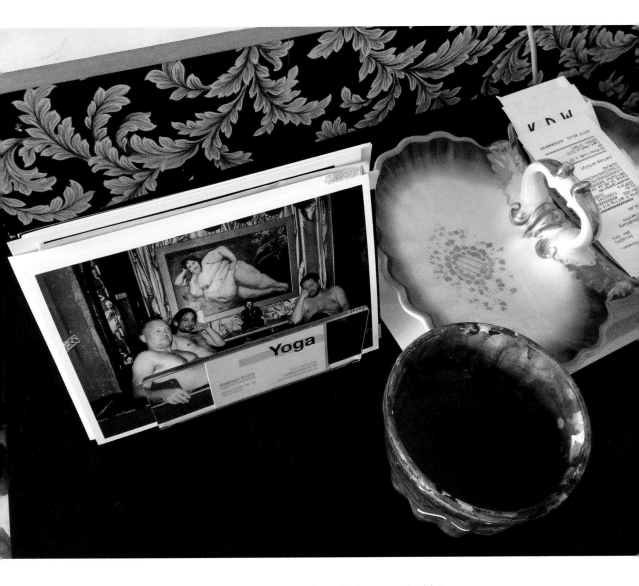

How do you look at art differently than everyday life?

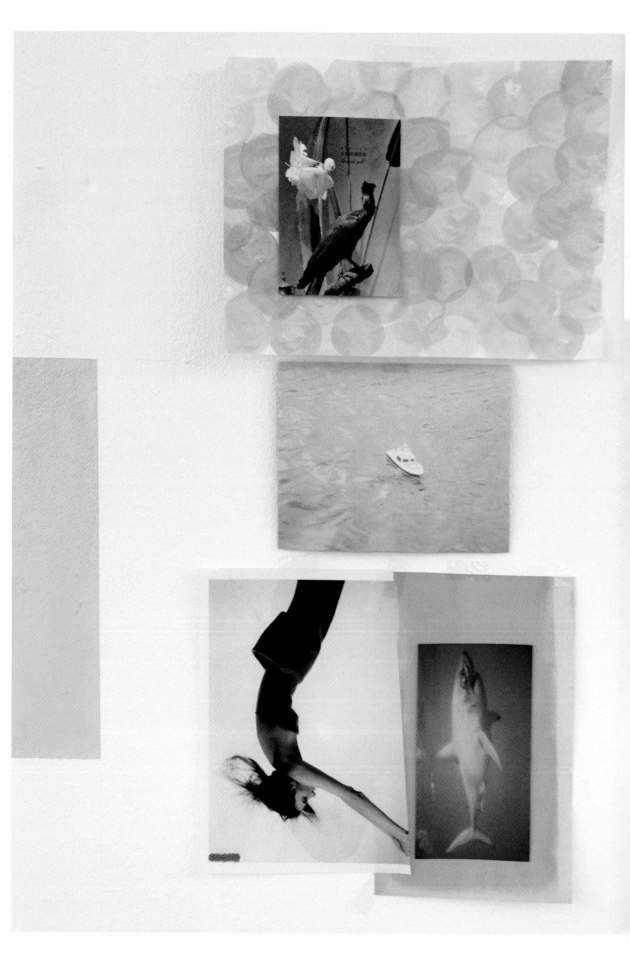

THINKING YELLOW

On Preferences, Dislikes, and Prejudices

Our memories retain impressions of color – not the colors themselves. These impressions are closely connected to specific images, and these in turn are part of a specific context: a time, a place—a subjective state of mind. It's not the color tone alone that determines our feelings—the circumstances it's embedded in play a significant role in our evaluation.

What is the significance of color in everyday live? How do factors such as culture, the generation we belong to, gender, individual and collective developmental histories, and personal feelings affect this evaluation of color?

Is there truly such thing as a color tone that helps us think? And if so, what does it look like? Where and how do I picture it? Who is to say that yellow is joyful and brown promotes boredom?

Our responses to these questions are shaped by memories and expectations. How we evaluate color depends upon our preconceptions and associations. After all, these preferences determine the direction of our gaze, blinding us to certain color tones and making us especially receptive to others. For any design work associated with color, it makes sense to be aware of these interferences and to pick apart each link in these chains of associations that are so habitual we tend to forget their existence. After all, these associations veil our perception and obstruct our ability to discover and precisely analyze the interactions of color. A change of viewpoint may free your view on color from preconceived associations.

We make decisions guided by color faster than we can think. Color precedes form, thus colors help us orientate ourselves faster. Could you envision a world without color? What would drive your decisions when you are shopping, when you are eating, when you are getting dressed or decorating your house? Is there a specific color you could imagine living without? And which color would you consider an indispensable companion?

stress

Can we link an abstract concept to a certain color? What repertoire of references and evaluations comes into play when we do this? Is there a form of color coding within our systems of interpretation? What is the origin of this specific color connection? What makes us associate yellow with stress? How does yellow suddenly acquire a metallic quality in this context...?

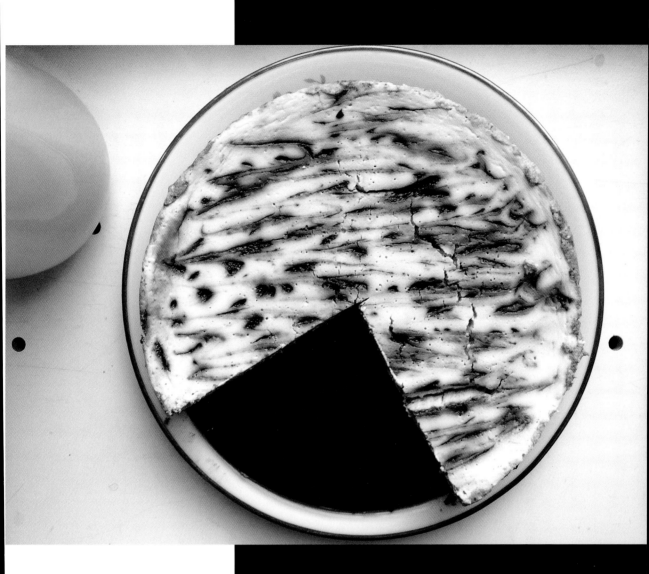

TASTE

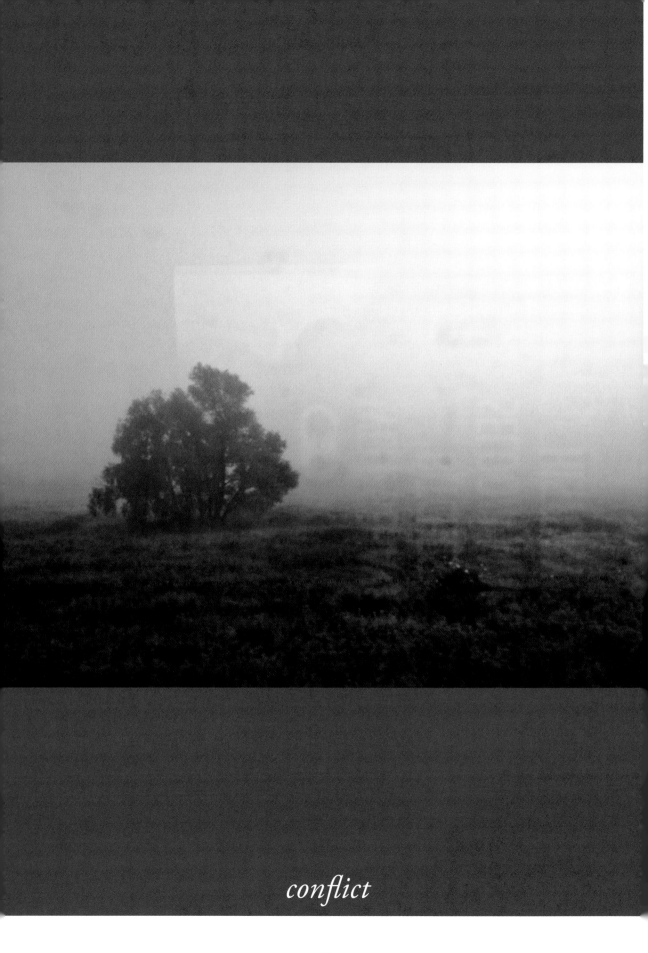

conflict

Most of us are familiar with surveys on the psychological effects of color. People are generally asked for their color preferences. They are also asked to assign colors in line with conventional patterns of interpretation. What is the color of love? What does yellow symbolize? We are also familiar with associations such as green with hope or envy, yellow with cowardliness or envy, and blue with yearning or technology.

These surveys rarely make any distinctions within the color tone, generally confining themselves to the difference between light and dark; the terms used in the questions are, similarly, often handled in a way that does not allow for ambiguities without differentiation. As a result, the answers are just as unconsidered and conventional as the questions. On the other hand, if you are challenged to switch on the Kopfkino, your mental cinema, the spectrum the spectrum of colors and associations expands remarkably. After all, as soon as you are asked to describe a color tone precisely, linking it to a personal experience or a specific emotion, a far more differentiated image emerges.

What is the color of success, of despair, of work? How do I arrive at these associations and what signposts am I following? Does the shade I have in mind have a certain smell, a taste, a specific surface? Now think about your favorite color again. Where do you envision it and how does it feel?

COLOR DIFFERENT FROM DAILY LIFE

The following format lists everyday terms that come with a certain loaded meaning and common connotations; terms whose fields of application include advertising. The intention here is to come up with a corresponding color association. Then, the task will be to describe both the color tone and the corresponding derivation as accurately as possible. This is not about a concrete true color impression from memory (see "Flashback", p. 78), but about free and personal association, from your present day perspective. While doing so, try to dispense with collective attributions such as symbolism or conventional patterns. The core of the question is:

Why do I see age as brown? A cowl? Withering? What is the color of poverty? Is the concept of "home" something individual? Advertising constantly bombards us, manipulates with these associations. In doing so, it connects with collective consensus meanings: warm gold and honey-colored tones are associated with luxury, blue with technology and reassurance, orange with safety, and green with health and nature. Sometimes, this process goes awry, simply because the wrong color was used for a new chilled drink. Take your time. Comb through your internal image archive. What colors spring to mind, and how do you explain that association? What is the corresponding image? How unprejudiced are your judgments? When do you envision pink?

progress

conflict

poverty

experience

sex

religion

stress

success

confidence

old age

COLOR
RECOLLECTION

Individual color memory is a little-researched and reflected field within our architecture of perception and our communication with others. My objective is to set this field in motion; to follow conscious and unconscious patterns of interpretation and paths of processing through conversations, exercises, and experiments and thus to raise sensibility for color perception. Flashback investigates our memory of and through color. In correlation to a childhood photo album, nine key terms are introduced, each of which must be allocated a shade of color that we remember visually in association with the context in question. The point is not to allocate it an associated color from today's perspective but rather to recall the memory of a concrete color impression; to revive it. It is therefore important to define the bearer of the color and to describe it as precisely as possible. An example of such a thread could be: school—honey-brown—slugs on the sidewalk (on the way to school). This approach investigates whether and to what extent memory of and about color can be pinned down and how available access to such knowledge is. There is never an appraisal in the classical sense, on the contrary: "the way is the goal." It invites you to roam your inner images and it provides insights into the individual color *archives* as well as sensitizing to seeing color. Given attributions are collected and saved under the corresponding term. This *collection* allows observations of whether and in what contexts allocations of color can be made available, how often the corresponding color-bearer can be named, what areas the references derive from (clothing, interiors, nature, etc...) and whether and what kind of group-specific correlations (age, gender, occupation) can be found. As memory is flexible so are these linkings. That becomes obvious when you do the test over at another time, maybe in a different mood, and thus may come up with very different images and corresponding color attributions.
www.farbarchiv.de/flashback

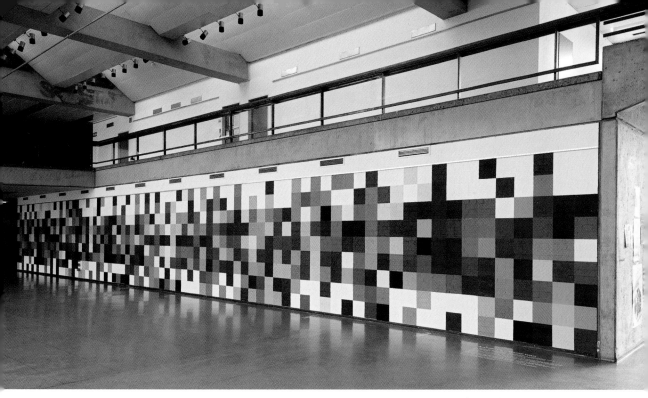

FLASHBACK—White Wall TU Berlin 2014

HOME

MOTHER

SCHOOL

FATHER

FRIENDSHIP

GRANDPARENT

SECURITY

ANGST

AFFECTION

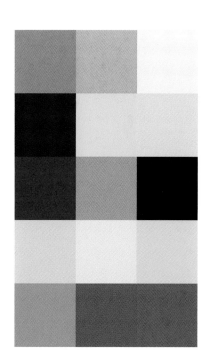

evening attire designer jewellery angora gloves
eyes leather jacket blouse
underwear wallet handbag
sweater hair apron
knitted sweater pillow case

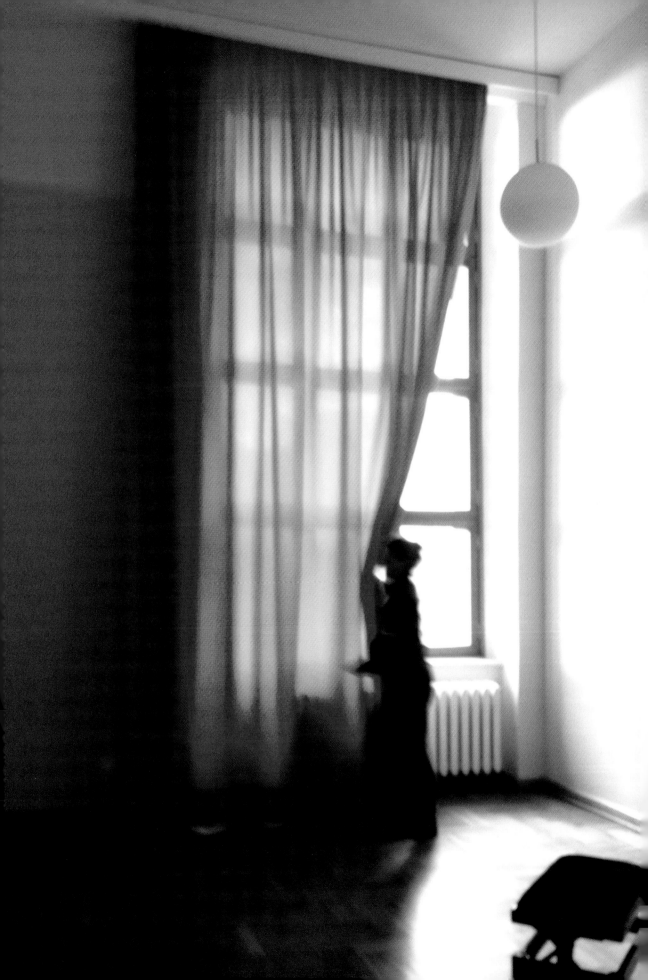

COLOR

IN

SHAPE

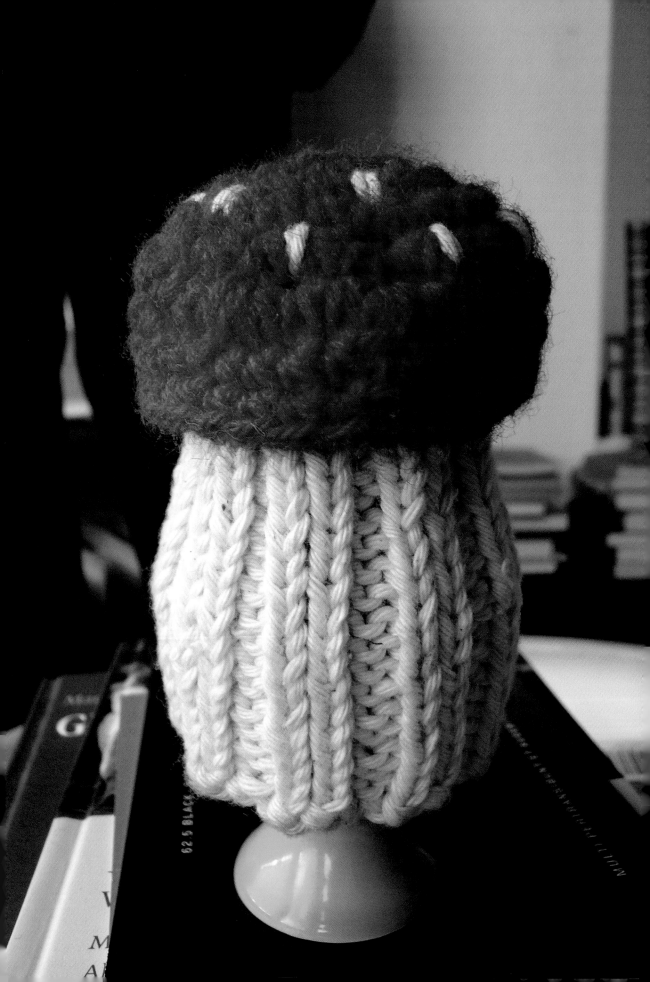

Touching RED

- Close your eyes and see. What shape does a warm red have? What does its
 surface look or rather feel like?
- No doubt, a warm red has a belly. Clearly, a deep warm red has a belly.
- Is there something more to go along with this belly?
- No, but this red has sort of a furry surface, and it is moving in a way.
- Some kind of animal?
- No, there are no limbs of any kind, no direction in which to move... more like a plant.
- You mean an organ, a heart maybe? Actually yes, a warm red is a heart, that makes sense.
- No, no, more like a vessel, a surrounding environment! But not an organ, no fluids.
- As in dry? Not the uterus trope? After all, dry no longer feels warm, dry means hot,
 a heat which let's the blood thunder in your head.
- No, no, no! I rather see it as something you can lay on. Like a blanket or a carpet.
- Didn't you have a plant in mind just now?
- Well, yes, but now that I think about it, a warm red is something that surrounds you,
 not something that you can grasp or take in your hand, for instance.
- No body, but just a surface?
- Precisely. The warm red is a surface with a belly. A surface that is moving,
 moving me along with it.

A dialogue between Ute Rückbusch and Günter Teerhob. Feldis, Switzerland, on August 8, 2011

Does a color also have a specific shape?

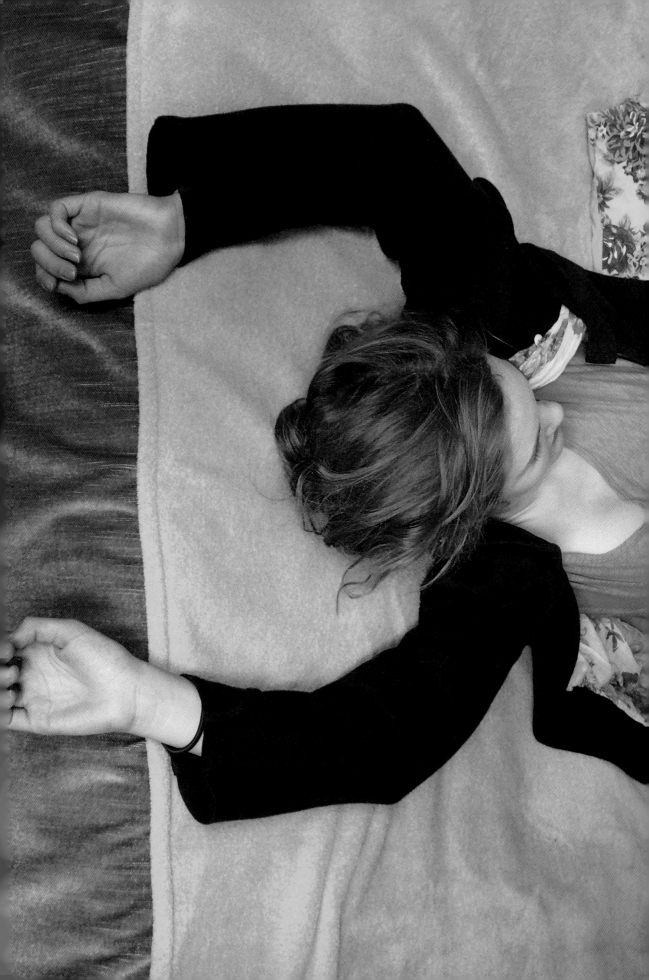

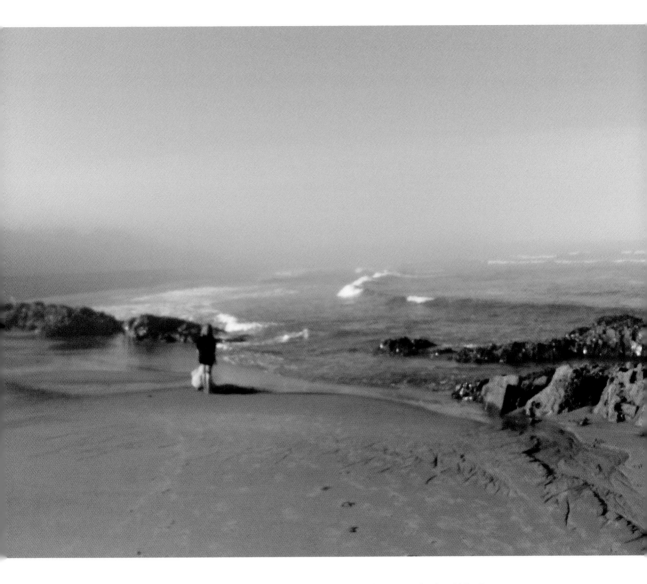

Can you describe a sensation of red while looking at a shade of blue?

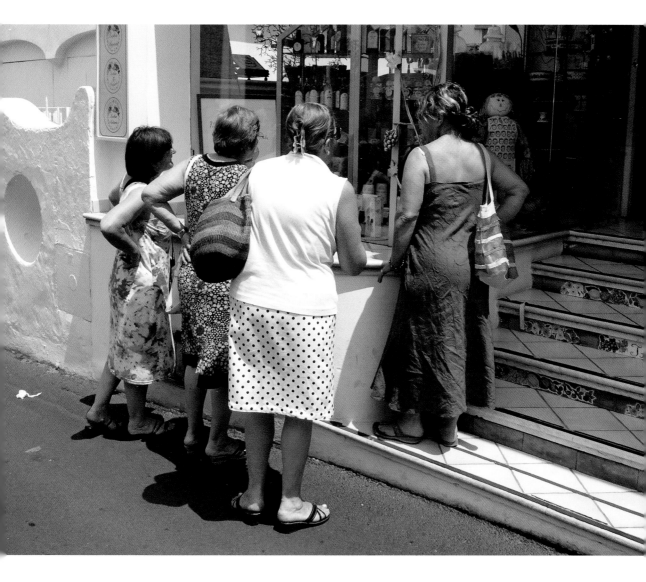

What color did you first grab getting dressed this morning?

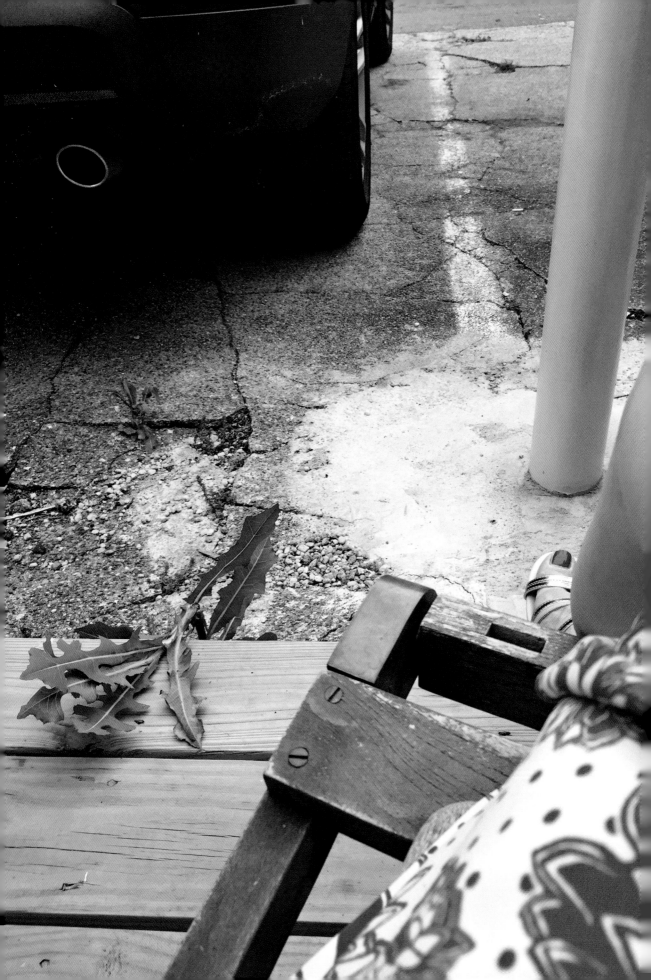

Knowledge, experiences, and accordingly preconceived judgements tend to obscure our view on color. This in turn affects our ability to precisely analyze the effects and interactions of color.

Try to look at your surroundings through the eye of a painter. Blend out knowledge and preconception and instead concentrate on color combinations. You may discover the vital role played by that little dot of red in the rear left, or how the whole scenery looks different, once you cover the yellow in the foreground with your hand.

Compose an imaginary color palette for what you see. Try to store these images in your memory locker, add them to your personal color archive and hope they come back to you when you need them.

Some people are equipped with a fourth cone giving them an exceptional sense for color. Interestingly, this phenomenon occurs more often in women, while men are more likely to suffer from red-green color blindness. Equipped with this additional cone, the spectrum of observable color expands significantly due to a greater ability to differentiate between colors, in so far as the color perception is processed by the human brain. While the ability to recognize a greater spectrum of colors may sound intriguing, it most likely verges on overstimulation. How relaxing by contrast, then, must appear the view of a landscape during the blue hour, when shortly before fading into nights darkness the scenery is shrouded in an indefinable blue (casting a bluish glow).

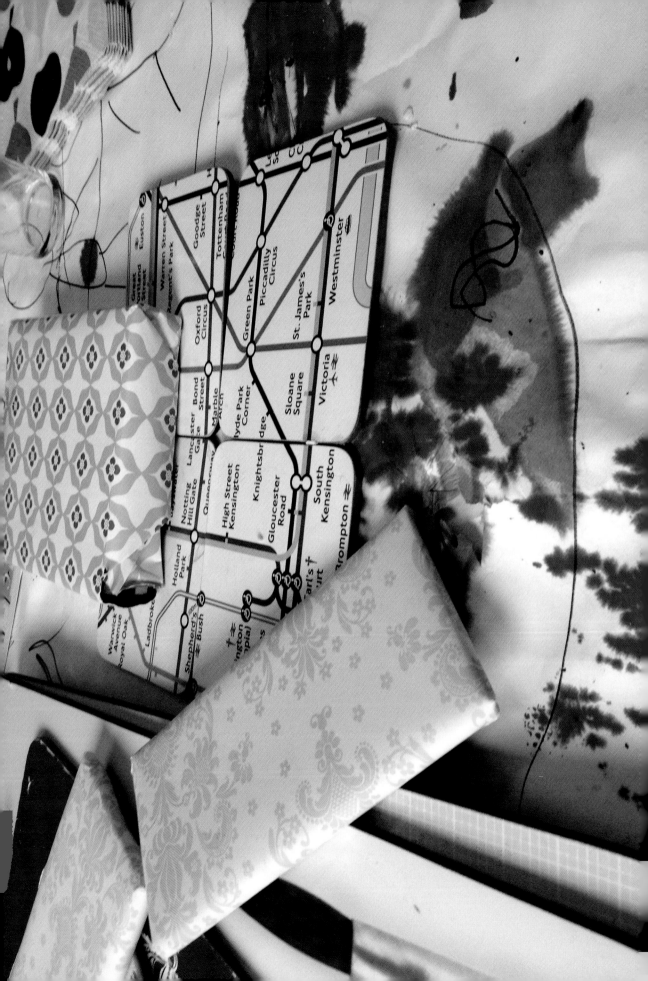

SAMPLE
AND
PROJECTION

When we talk about colors, we generally compare them to each other or use analogies to describe them. Context, widespread habits of seeing, and specific applied circumstances are critical to our judgment of color. What are your reference points, your criteria when you evaluate or describe a specific shade?

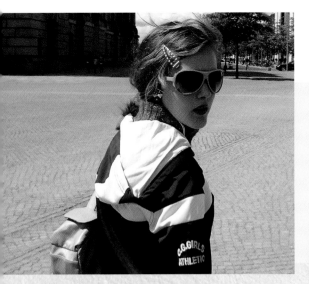

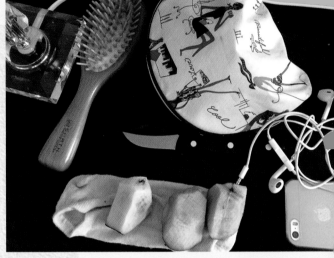

udy skies over Trier lard in Grandpa's ears facebook sun died hair curry-veggie-soup beer lemon tart candy drop berry mom's frozen
rries pea from the can black hole dirty beach sand scrambled eggs text marker concrete rosemary sage mashed potato fog at sunrise
rcoat from "the little prince" bread rolls recycled glass container margarine wiener sausage peach watermelon garlic ten-euro bill
emburg mustard avocado cream my dress summer rain butter Boesner cutting mat green olives in oil grass in late summer outside
t before night police sweaters traffic light green fogged aquarium windows dove tail feathers Volvic water bottles white-out bottle
s Haribo dolphin wine gums with mice track background Aral gas station red wine spot wet candied cherries darker even wetter tone
key mouse ears banana puree boiled potato skins New York cab tomato soup with a lot of cream at the edge of dried grapes dark
colate curtains in grandma's house 70s bathroom tiles special offer signs Easy Jet vanilla pod rainy Sunday afternoon in Neukölln slugs
he ground on my way to school Sabina's hair my new angora pullover pumpkin pie

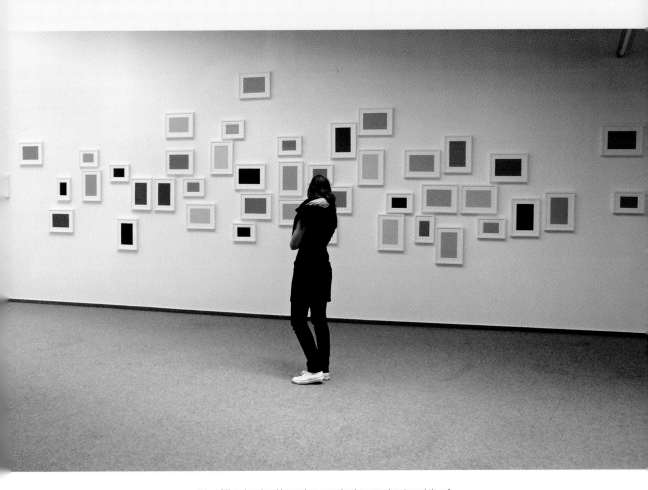

"I just fill my head and hope they come back to me when I need them"
Sample & Projection, Architekturpreis e.V., Kutscherhaus, Berlin 2010

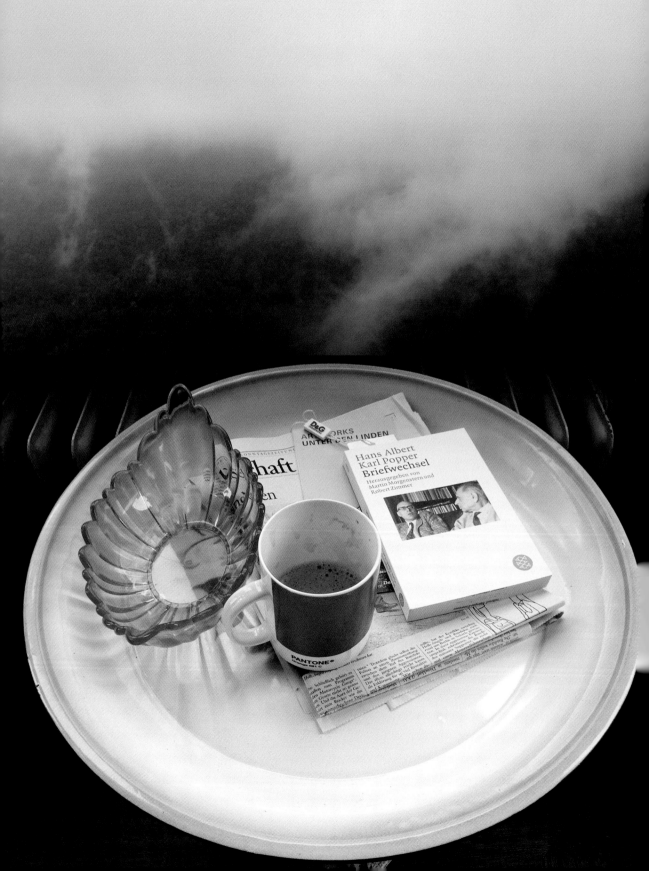

ROASTBEEF

Calling a color by its name

Look around you and find a color, or recall a color and think about the impression it made on you. How would you describe this color? What would you call it? Take pen and paper and write it down. Remember that color is a comprehensive sensation. Color is a sensory experience, so in order to evoke it be accurate and include all the sensory impressions that accompany the experience. A color visualization can be brought to life by giving qualities to the color impression and illustrating it with images. A color can definitely be experienced (and described as) scratchy or quiet, round or angular, even "honest"—anything that helps the imagination of a color impression.

You probably experienced the color you are thinking of in a specific context, so you should consider the accompanying circumstances and features. Include everything that comes to mind related to this color; this will help you and the person you are talking to get a better picture in their mind. You may be creative, though it is essential that you share a common context, so it is understood what you are referring to. The Facebook "Like" Button for example is a reference frequently chosen by students to point to a specific blue. An old person without Internet will probably be less inclined to follow that image. Contrary to the Coca Cola Red: probably anybody anywhere regardless of generation or context will be certain to point out that color tone.

Now, look at your color descriptions and names. See if you could not simply eliminate the "red" or "blue" in the description. Go ahead and list every sort of criteria that qualifies to describe a specific color impression, even if they are not part of your own collection.

UNCLE DAVE

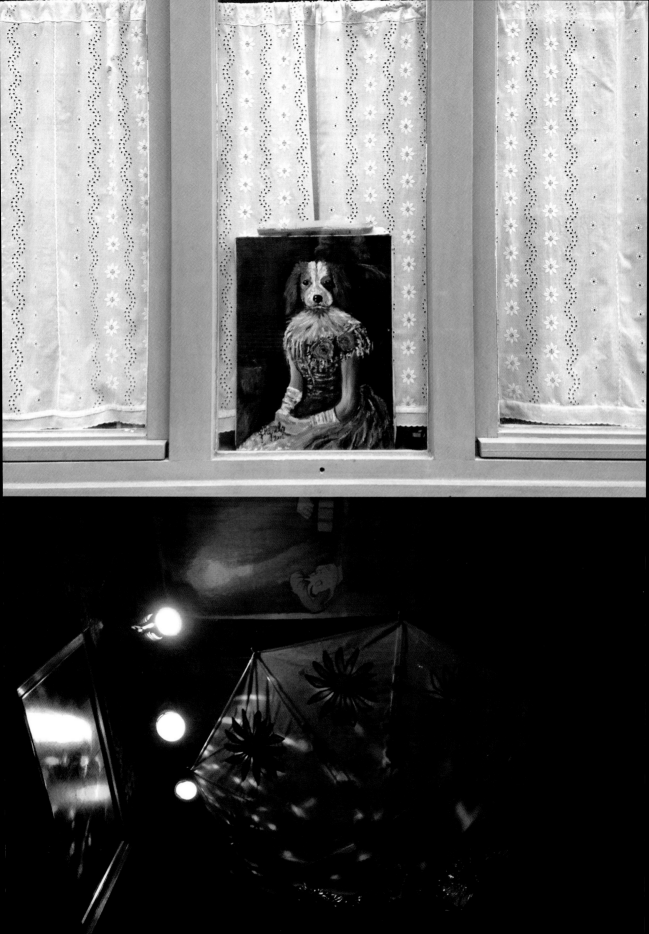

SQUARE BOX YELLOW

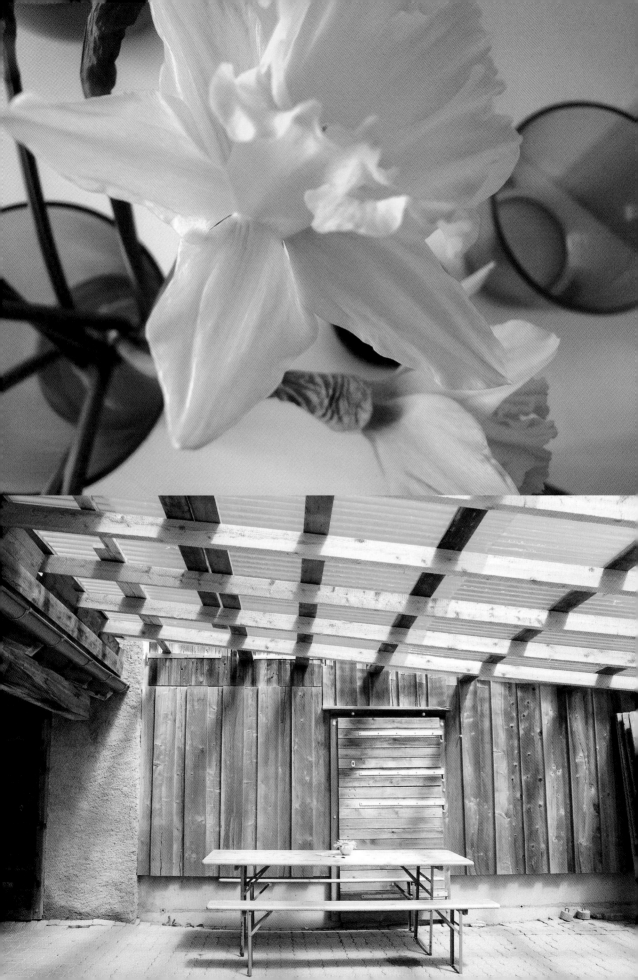

CRUSTY BEIGE

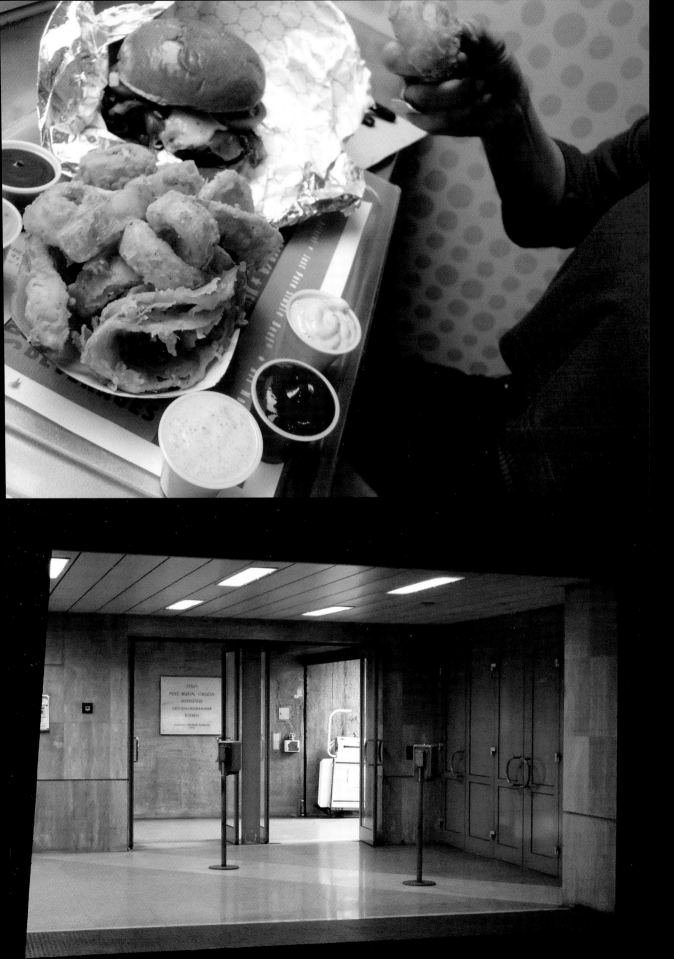

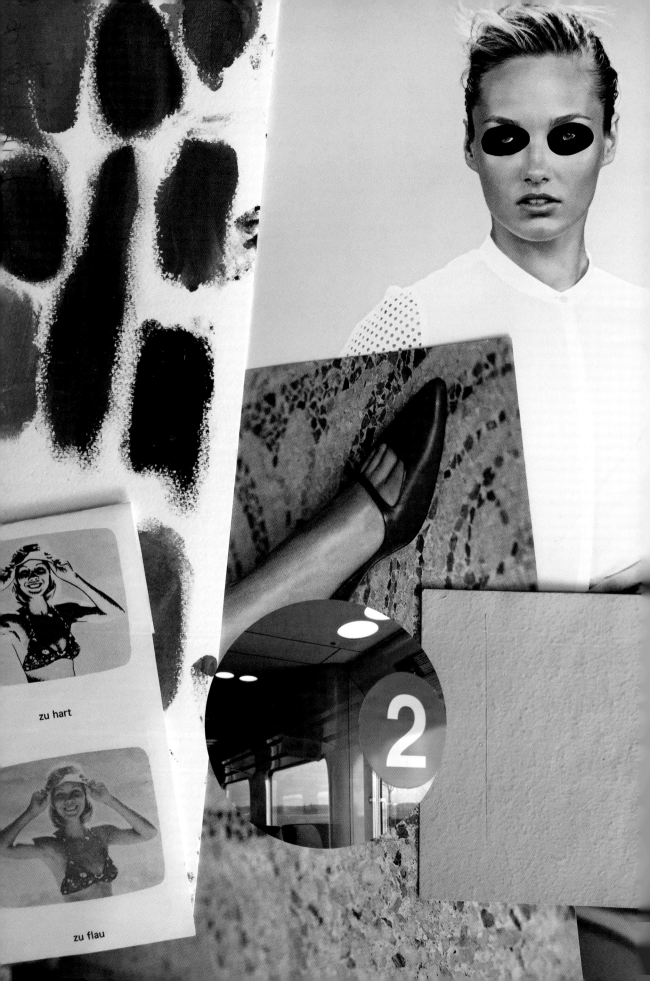

zu hart

zu flau

2

COLOR STOCK

EVERYWHERE

How we see, what we see, and what we think we are seeing are questions that should be thoroughly considered in the interests of arriving at a better understanding of color and its effects. How we evaluate a certain shade depends not only on its neighboring surroundings, as mentioned earlier, but also on indirect aspects such as cultural context and individual disposition as well as time and location.

The color I have in mind, the shade I may envision at this moment: where, when and how did I experience it? On my last vacation, feeling relaxed and receptive in a picturesque setting in the Carribean, or in rather less charming surroundings on a rainy day in New Jersey, feeling hungry rather than relaxed?

Visual perception always depends on context. For instance, we see objects in an art context or when we are travelling in a significantly more unbiased way than in our everyday surroundings. Because of the frame of mind that we are put into by their presentation, we discover shades and shapes that, in a different setting, we would entirely overlook. Or we may admire colors in fashion and interior design magazines and carefully select shades and combinations from their color charts when we would not look twice at the same colors if we saw them elsewhere.

Try to blend out such embedded associations and instead focus on the colorfulness itself. Look thoroughly, regardless of whether it is a hip blog or a cheap bargain table. Collect color samples, photos, printmaterial, anything that catches your eye. Try to save color impressions like an imprint, store them in your color memory collection and hope that they come back to you when you need them. After all, the best guarantee of being able to work confidently in the medium of color is to carefully observe all interactions that have a bearing on its effect, with a view both to everyday surroundings and to the nature of sight itself.

TERRACOTTA

BOLOGNA, DETMOLD, NIEDERKASSEL

When it comes to introducing a painterly Mediterranean atmosphere into central German cityscapes and living spaces, then it is time for terracotta— or rather, for the idea of terracotta. Few other color tones come close to it as favored shorthand for remembered or imagined sunshine, warmth, and well-being in a picturesque southern setting. When removed from this context and placed in different light conditions and changed surroundings, however, terracotta reveals its other face: after all, it is brown, and does not look the same in Berlin as it did in Bari.

A color tone cannot simply be transferred from place A to place B. Apart from the light, directional alignment, materials and dimensions, spatial structure, temperature, and acoustics also have an impact on how an environment— and its coloring—affects us. Careful "translation" and color adaptation is required when you want to bring the atmosphere of a sun-drenched bathroom in Tuscany to a small north-facing bathroom in Berlin. This may require a very different coloration to that originally envisioned in order to achieve the desired effect, but do not forget, it is never purely about color. Try to analyze the appealing effect you want to create: what do you associate with this effect? What are the accompanying stylistic elements? What colors might have a similar effect if combined differently? Try experimenting to see what works under the circumstances and with the on-site conditions.

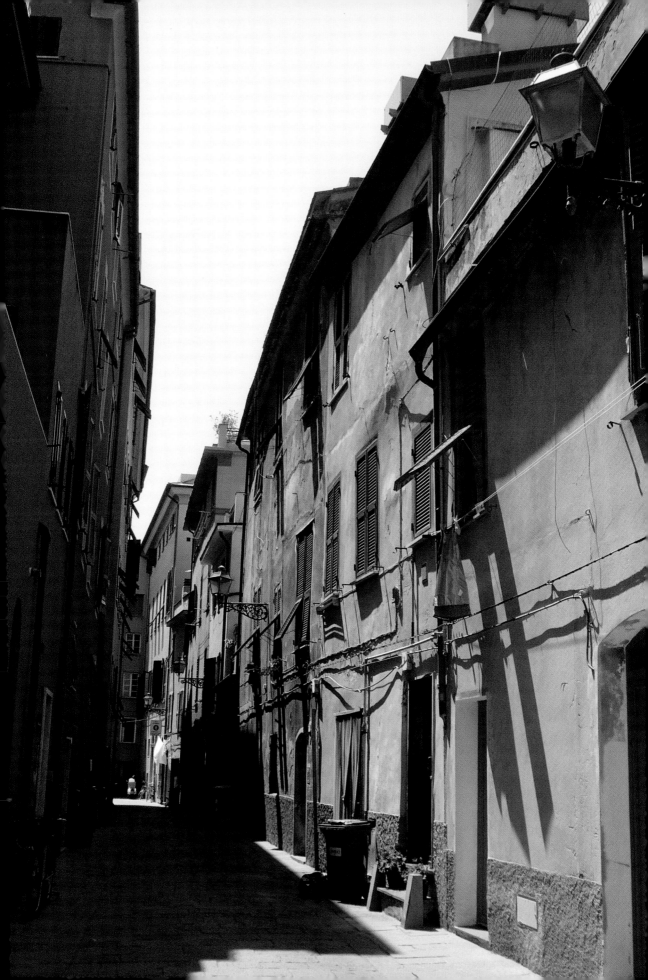

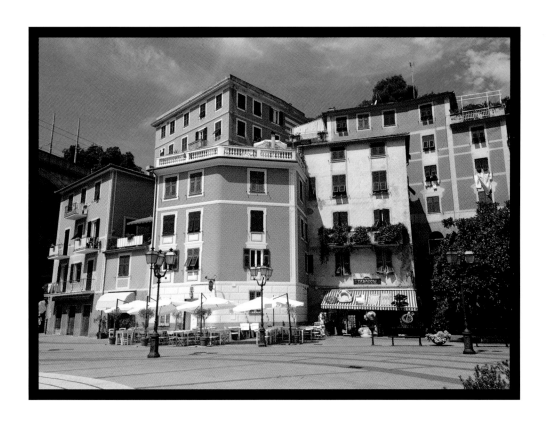

No other preconception is so common and at the same time limiting as that of the alleged natural chromaticity. In habitual language use, the colors of nature are earthy: warm reds and yellows as well as shades of so-called natural greens. In such context, people also no longer express dissatisfaction with the otherwise loathed brown. Of course, this color scheme predominately appears if we look from afar at the landscape—often referred to, romantically, as nature. And yet, nowhere else do colors appear as rich and bright as in nature. Under close examination, the familiar fall scenery shows a great variety of intensive, full-bodied yellow, orange, and red tones. And there are a lot more, flora and fauna deploy a wide spectrum of flashing colors to attract or divert attention. Thus, the allegedly natural shades are actually less a matter of nature's display but rather more of human misperception and shortfalls in production technology, as many bright paints can only be produced synthetically. Of course in nature most of theses intense colors do not usually appear on a large scale—except for some sky scenery—and they sure do require sensitivity in design processes. As accents or highlights though they play an important role. The right measure, the embedding and the context make the difference.

Above: an example of how color cannot fix everything. What architecturally, if you can even use that adjective, went wrong with this building, cannot be resolved by applying an allegedly warm, friendly yellow—a repeatedly made mistake in façade design.

Color FINDING

When creating a color scheme for a space, the first things to consider are location, its architecture, and the actual purpose of the mise-en-scène. Look at the proportions, the access routes, and the lines of sight, check the lighting situation. The latter can vary in terms of temperature and intensity, depending on whether daylight or artificial light is used. The space may be light or dark. Significantly less lux are used in a museum than in a fitness studio. Light may be white or yellow. It may come from neon tubes, halogen lamps, LED lamps, or incandescent bulbs—all of which produce different colors of light. Even daylight varies as it changes over the course of a day. In most interiors light sources are usually mixed.

Bear in mind, a color is significantly changed by the angle, as well as the temperature of light: it makes quite a difference whether a color pane is vertical or horizontal; if it's on the wall or on the floor. This is why flexible sampling is highly recommended. Work with large sample sheets; unlike paint applied to walls, these can be moved around and tilted in order to check the color effect in different areas of the room.

Space design is not two-dimensional design in which the angle of light is the same for all colors. In a space, colors relate to one another; they interact and change accordingly. Delicate tones for instance, tend to become more intensified in the corners, with light sandy tones appearing to abruptly shift towards pink. When working with strongly colored surfaces, you should also bear in mind, that where the light angle and dimensions permit, they will throw back colored light. This is particularly apparent in small spaces with surrounding white walls.

Personally, I do not engage in the use of mood boards. They look smart and provide a good overview of the available color combinations, but they fail to take into account aspects like light incidence and dimensions. The color elements, when seen juxtaposed on a single plane—in a worst case scenario spread out on an office table under neon lighting—on which they are clearly separated from one another by the color of a background sheet, most often have little to do with the subsequent result. Such presentation shortens the power of color and makes it impossible to take into account volumes, depths of space, juxtapositions, lines of sight, and angle of light incidence—all of which are critical to the effect of color decisions! As mentioned earlier, rather work with flexible panes, that way you can check out different areas and you can also combine them with each other.

It is common knowledge that the nature of the surface affects the performance of a color tone immensely. The texture—matte or lustrous, smooth or textured—can significantly expand the modulation within a color space. In practice, there is, ultimately, only one proven way to adequately take into account the factors mentioned here: to look at samples on the actual objects, ideally on-site, on the appropriate surface, and in the right light. This stage is, of course, preceded by a preliminary selection phase, initially involving smaller paper samples, color charts, and material patterns. If possible, also look at examples, photographs, in order to get a better picture of the intended direction and the impression it creates.

It is difficult to work with color in the abstract—and many people have difficulty picturing it. Even more so, everyone may imagine it differently.
This makes it all the more important to communicate clearly about colors and their associated connotations before creating a color design. After all, sometimes we use the same term or the same analogy while thinking of an entirely different color effect.
That is where effectively communicating about color comes in, which is often ignored, underestimated, or underrated.

Co
HESION

Color provides cohesion, whether it be within a picture composition
or a spatial structure. A colored background holds together
what otherwise may seem to float around without direction.

Lay
OUT

Color arranges, rhythmicizes, and stages our environment.
It directs, stimulates, and neutralizes.
It lifts, separates, and unifies.

Pro
PORTION

How much of what, and in which shape or form?
A room completely colored, a confined area, or just a vase?
As strong colors may be challenging on a big scale,
they are very efficient as accents within an over all setting.

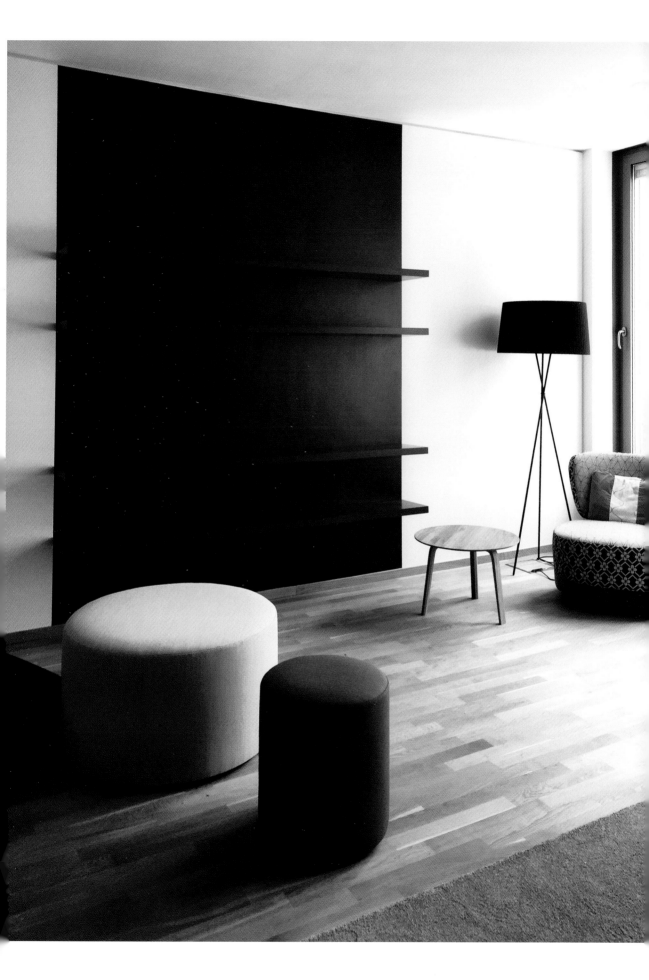

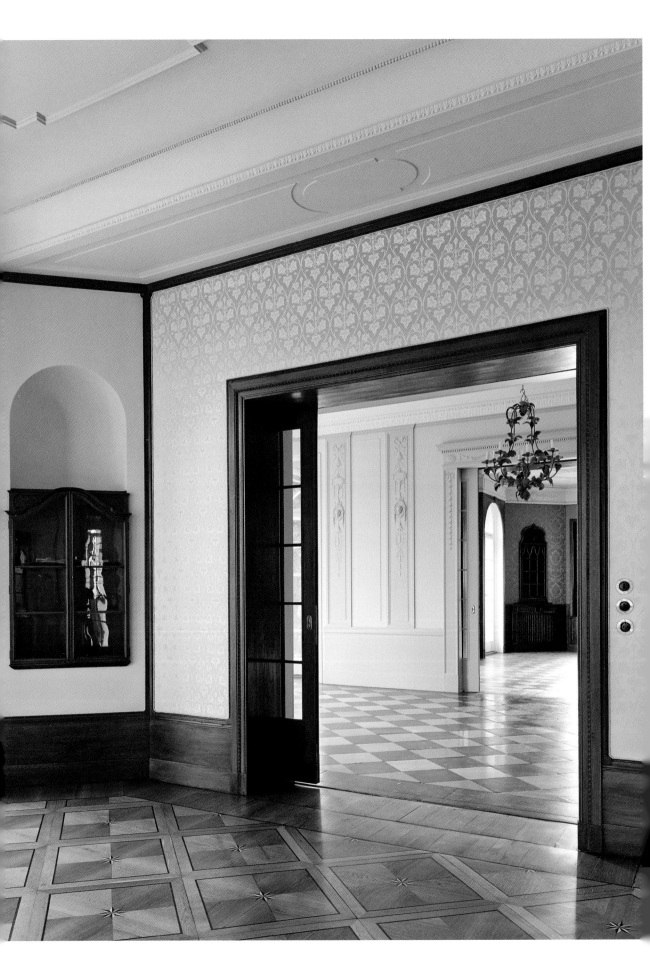

Visual
BOND

We see colors within a spatial context. That requires careful harmonization
of all color elements within the given visual and spatial structure.
Every individual color component counts no matter how small or slight.

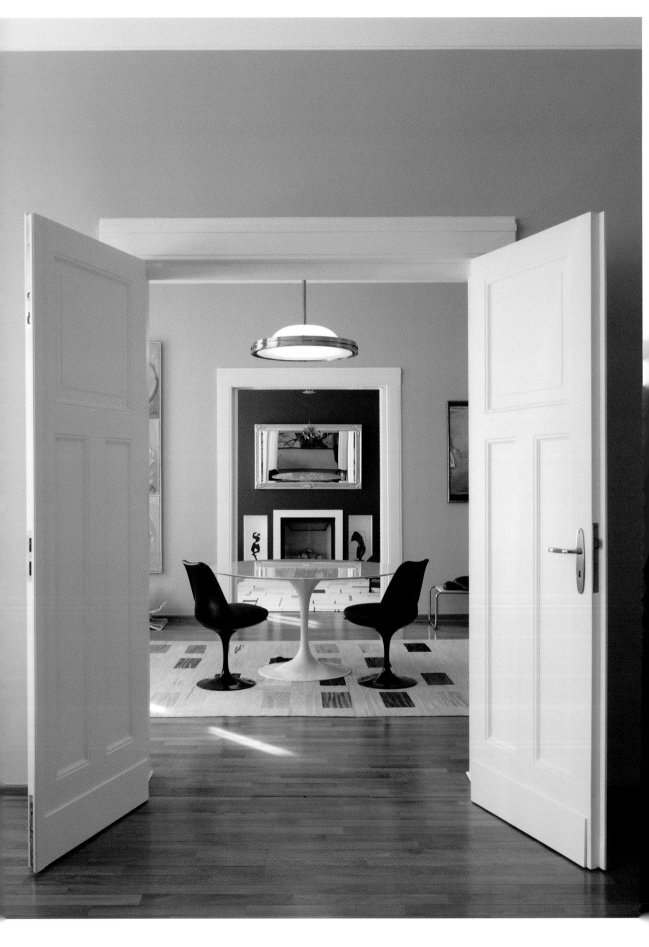

Sur FACE

Light and texture create modulation and diversity within a color setting.

PROJECTS

COLOR + INTERIOR DESIGN

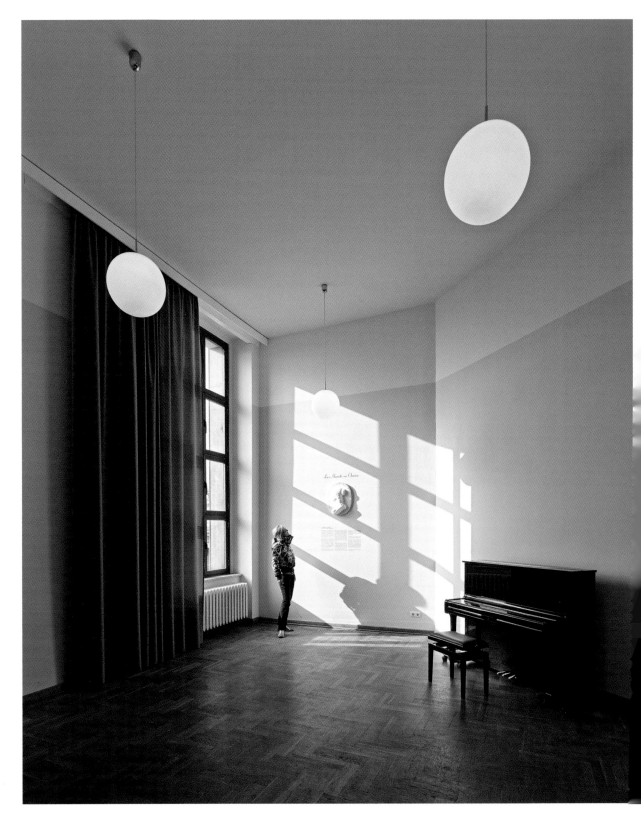

Luise-Henriette-Saal | Stellar

BERLINER DOM

RENOVATION OF ADMINISTRATIVE AND FUNCTIONAL PREMISES | BERLIN 201
FT: COLOR CONCEPT
CLIENT: BERLINER DOM

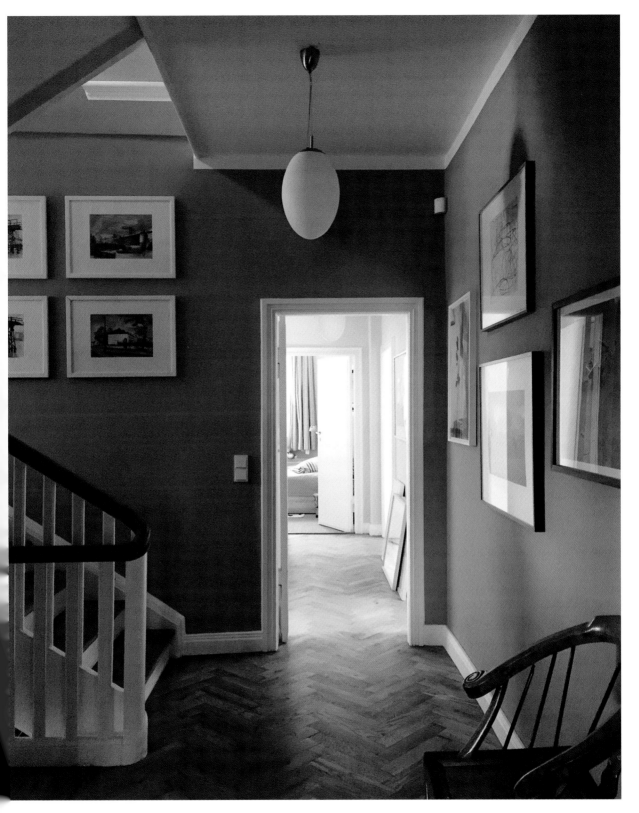

VILLA IN BERLIN-WESTEND

MAKE OVER | BERLIN 2015
FT: COLOR CONCEPT INTERIOR
CLIENT: PRIVATE

Pekka

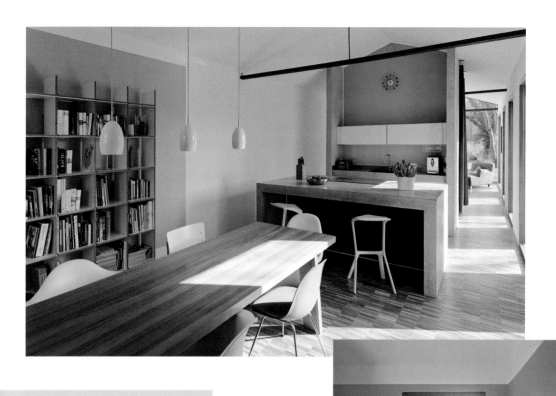

Eating | Buttertoast

Cooking | Rachel

Cooking | Quinn

Hallway | Nowadays

Music room | Caputh

Utility room | Elvis

VILLA D.

NEW CONSTRUCTION | POTSDAM 2014
FT: COLOR CONCEPT INTERIOR
CLIENT: PRIVATE

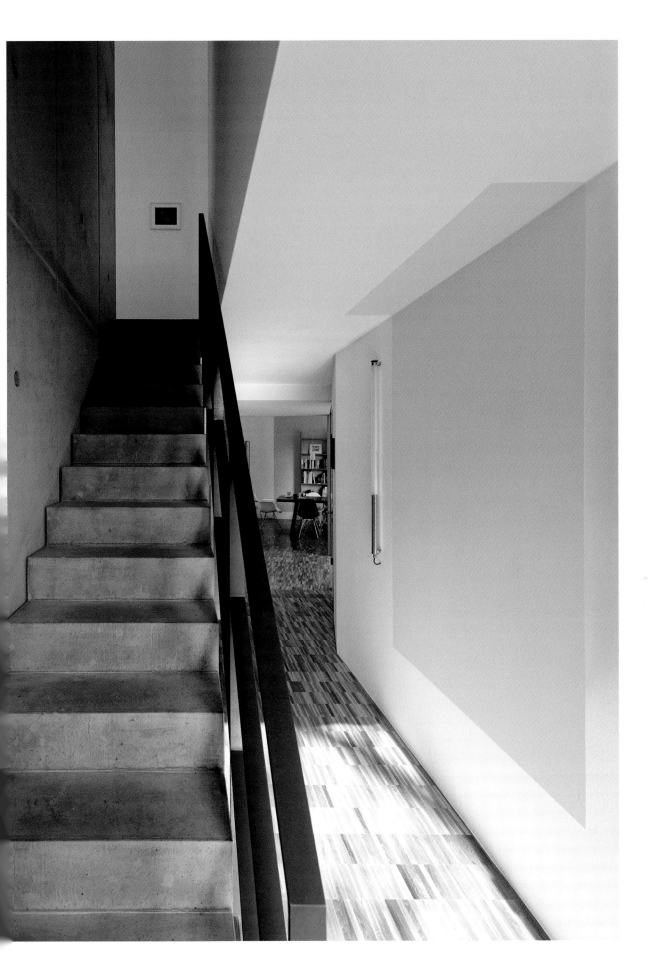

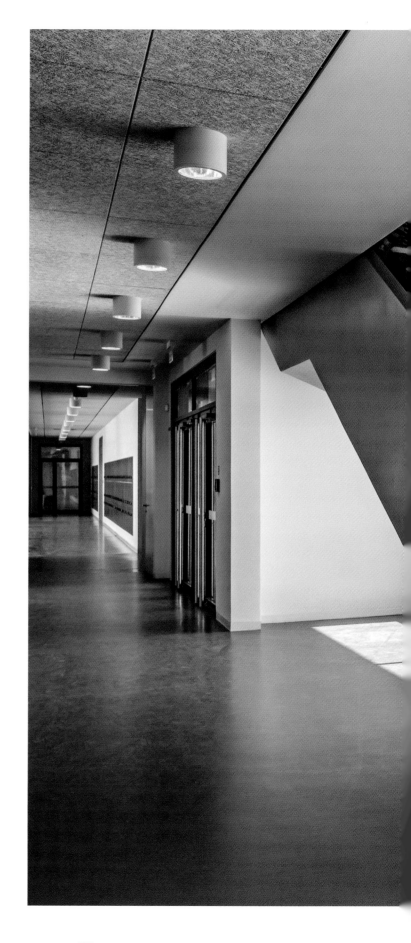

WILLY-BRANDT-SCHULE

NEW CONSTRUCTION | WARSCHAU 2014
FT: COLOR CONCEPT INTERIOR
CLIENT: VOLKER STAAB ARCHITECTS BERLIN

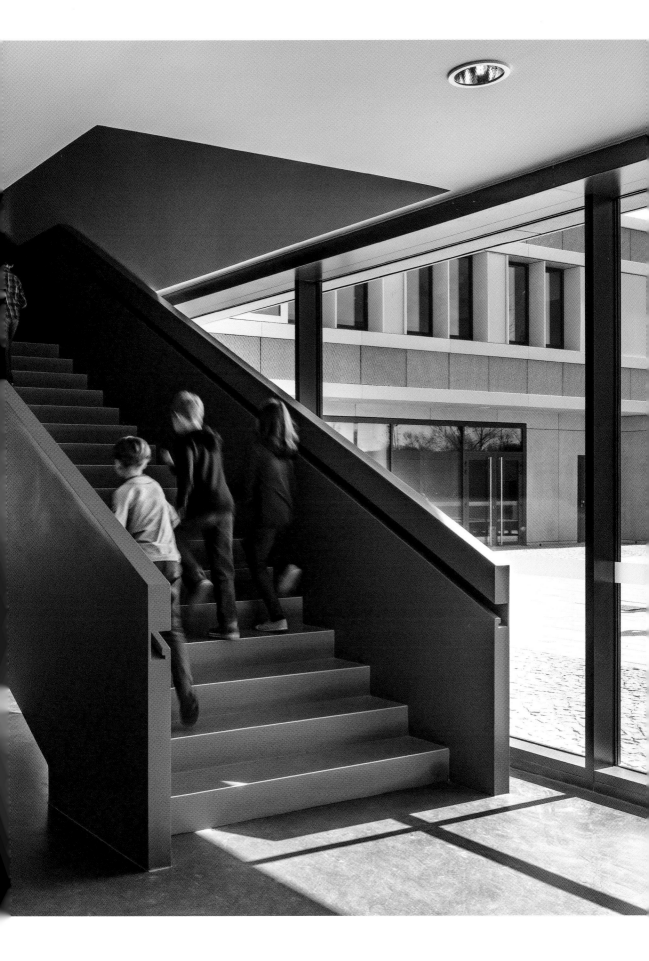

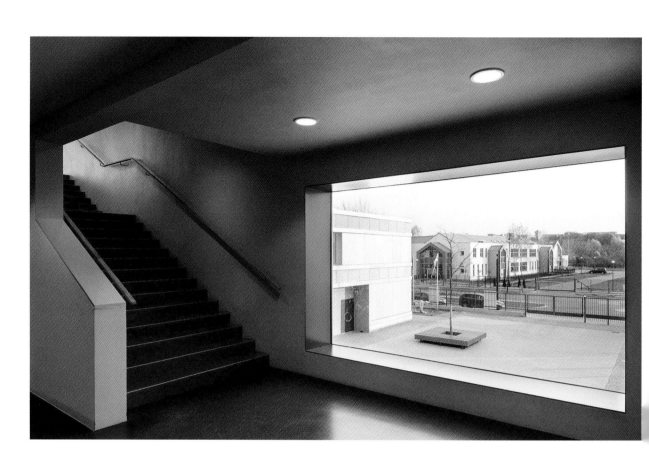

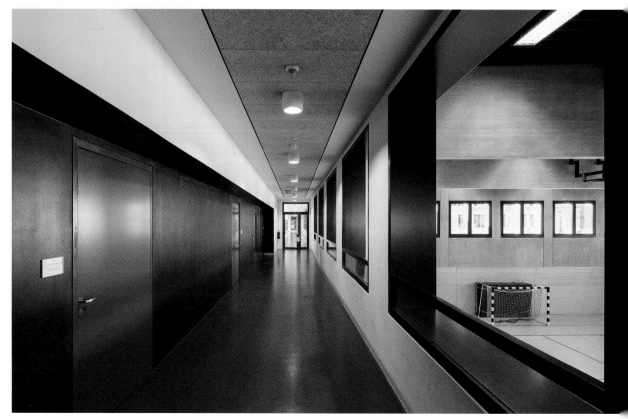

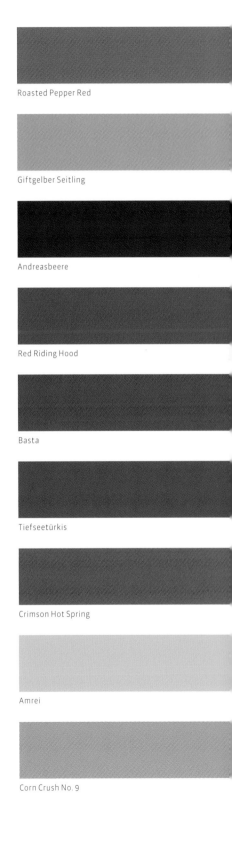

Roasted Pepper Red

Giftgelber Seitling

Andreasbeere

Red Riding Hood

Basta

Tiefseetürkis

Crimson Hot Spring

Amrei

Corn Crush No. 9

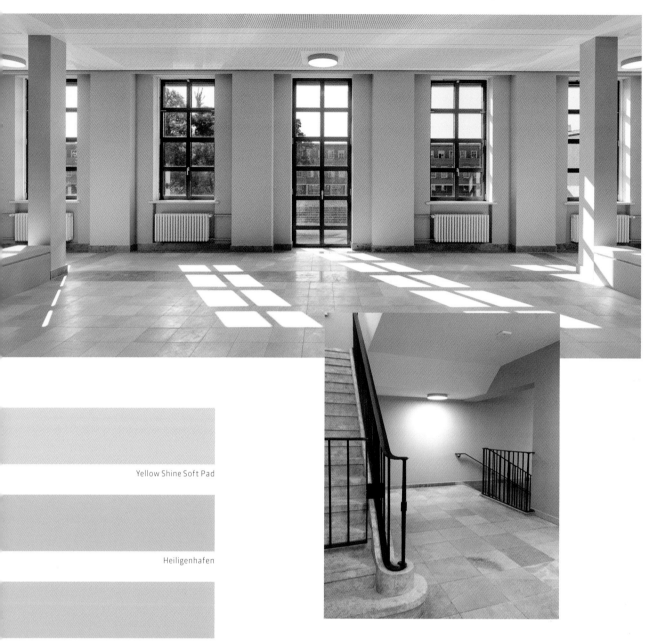

Yellow Shine Soft Pad

Heiligenhafen

Rauchsalz

Henna

Let Me Go

POELCHAU-SCHULE

RENOVATION OF A HERITAGE PROTECTED BUILDING
BERLIN 2015
FT: COLOR CONCEPT INTERIOR
CLIENT: MÜLLER REIMANN ARCHITECTS BERLIN

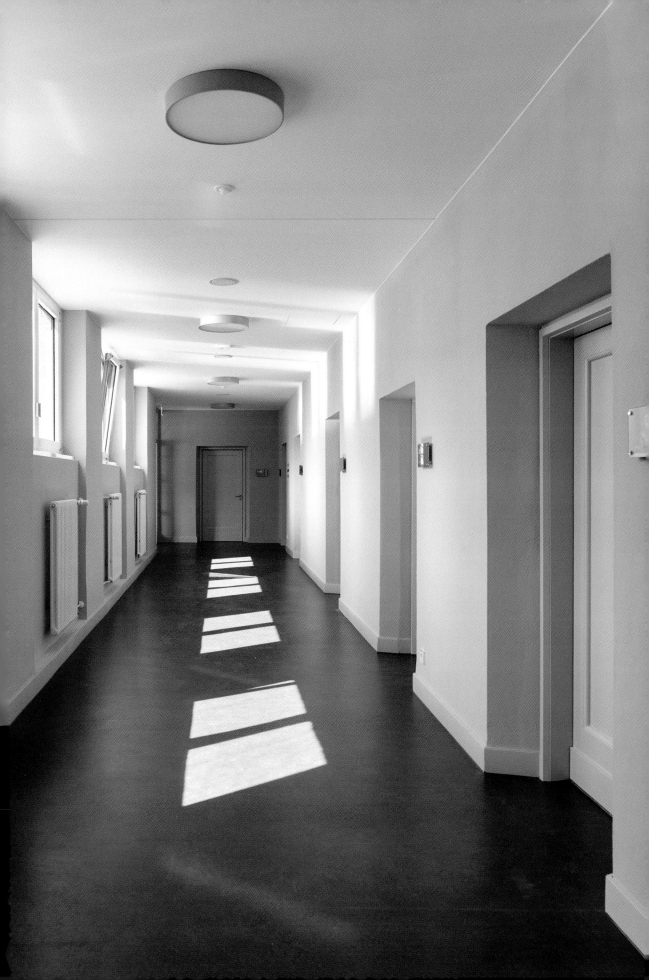

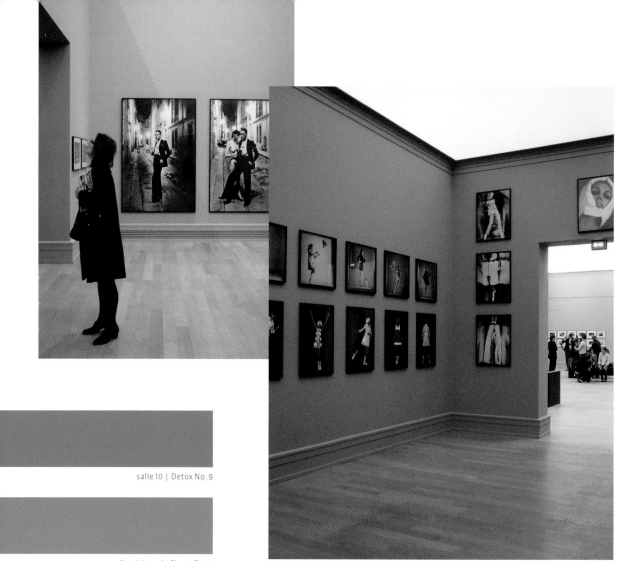

salle 10 | Detox No. 9

salle 1 | Lincoln City in Paris

salles 2, 3, 4 | Biarritz

salle 5 | Jessica Blushing

sections 6, 7, 9 | Bleumourant II

salle 8 | Hannover

HELMUT NEWTON—GRAND PALAIS PARIS

EXHIBITION | MARCH 22 UNTIL JUNE 17 2012
FT: COLOR CONCEPT INTERIOR
CLIENT: KAHLFELDT ARCHITECTS BERLIN

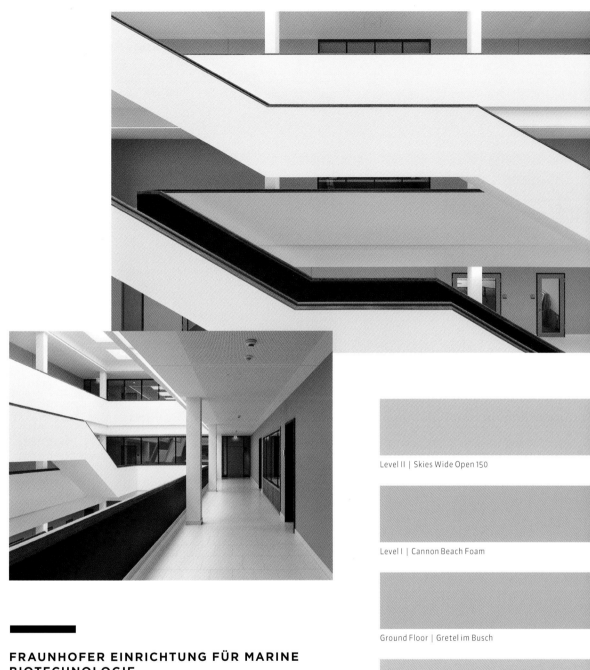

FRAUNHOFER EINRICHTUNG FÜR MARINE BIOTECHNOLOGIE

NEW CONSTRUCTION | LÜBECK 2015
FT: ARCHITECTURAL ART >> COLOR CONCEPT
CLIENT: FRAUNHOFER INSTITUT MÜNCHEN

Level II | Skies Wide Open 150

Level I | Cannon Beach Foam

Ground Floor | Gretel im Busch

Basement | Silver Scales

Interior / Exterior | Bleach 14

Exterior A | Weeping Peaches

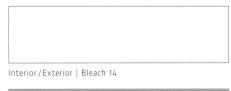

Exterior A | Big Valley

Exterior B | Turdus Merula

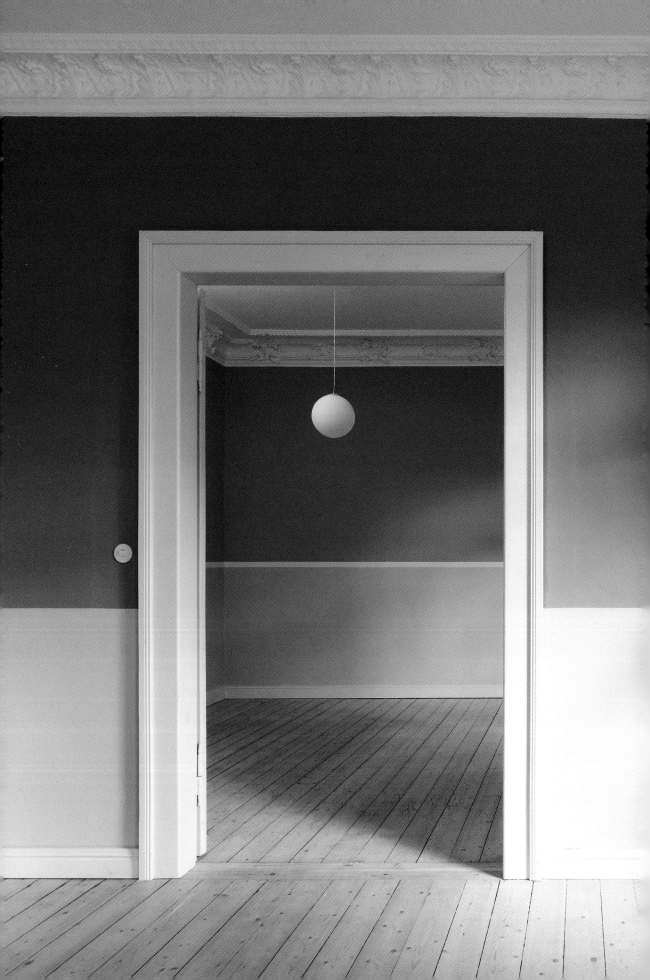

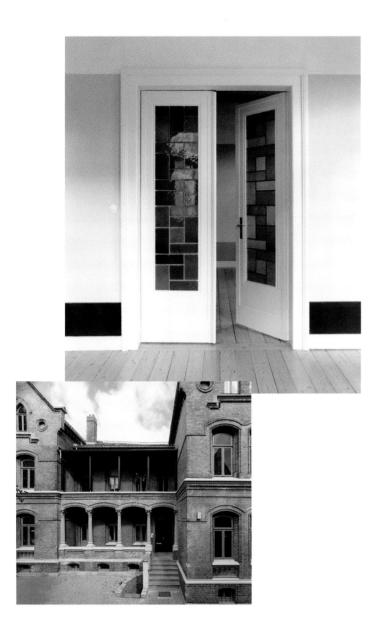

Blue Grace

Heiligenhafen

Plum Pie

Spring Fling

Dare Me

Tykka

Fresh Out of Water

Royal Blues

Different Today

STADTVILLA G.

CONVERSION AND RENOVATION | BRAUNSCHWEIG 2012
FT: COLOR CONCEPT
CLIENT: PRIVATE

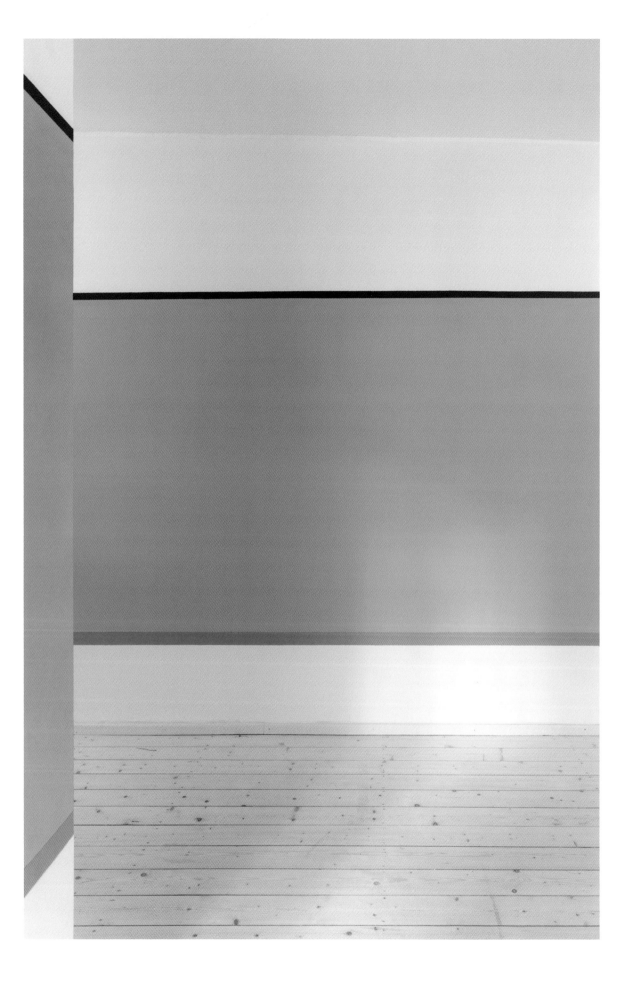

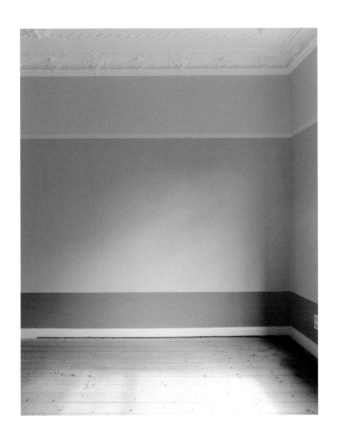

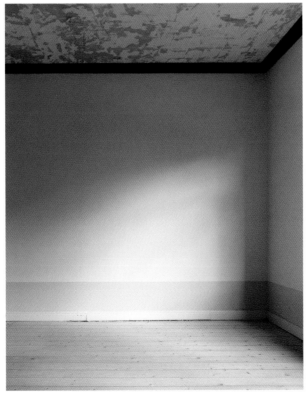

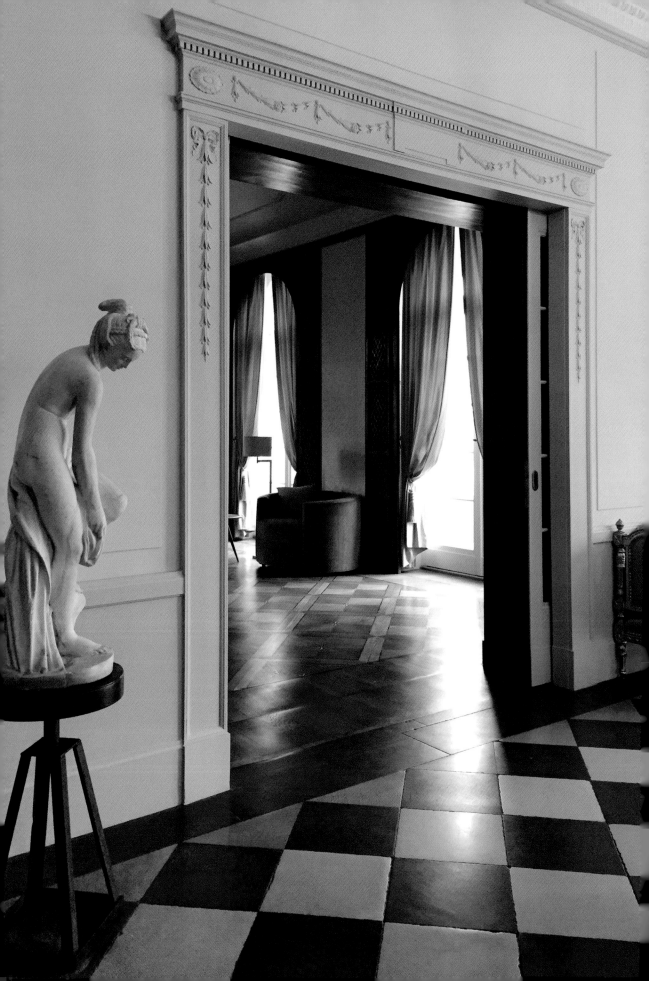

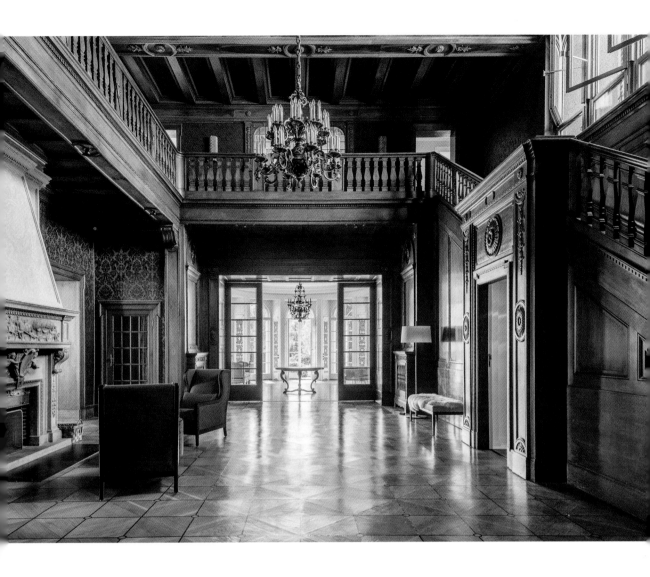

VILLA KAMPFFMEYER

RENOVATION OF A UNESCO HERITAGE PROTECTED VILLA | POTSDAM 2016
FT: COLOR CONCEPT AND INTERIOR DESIGN
CLIENT: PRIVATE

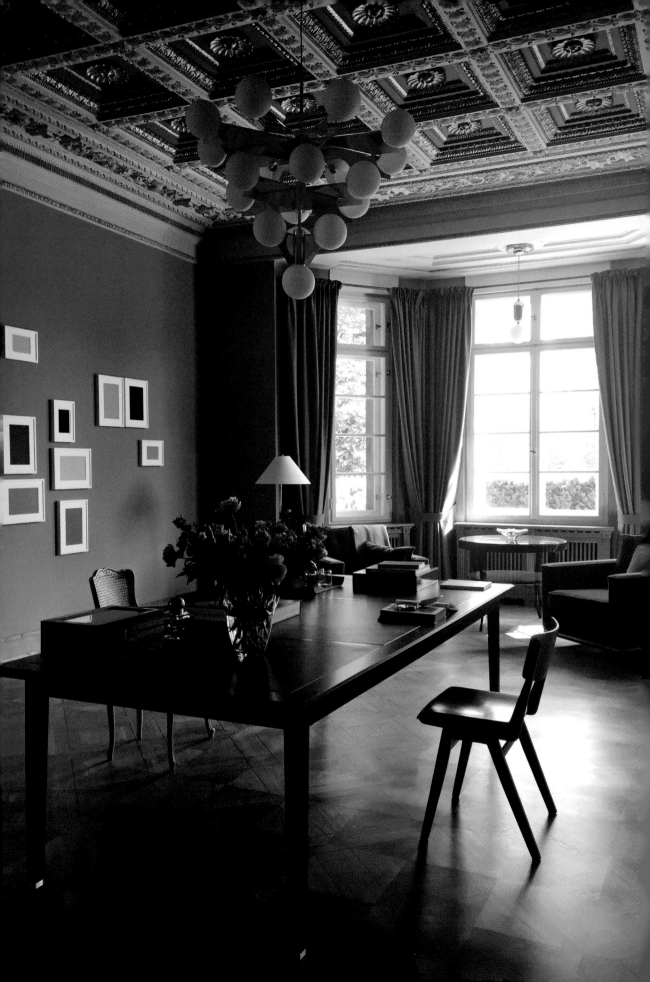

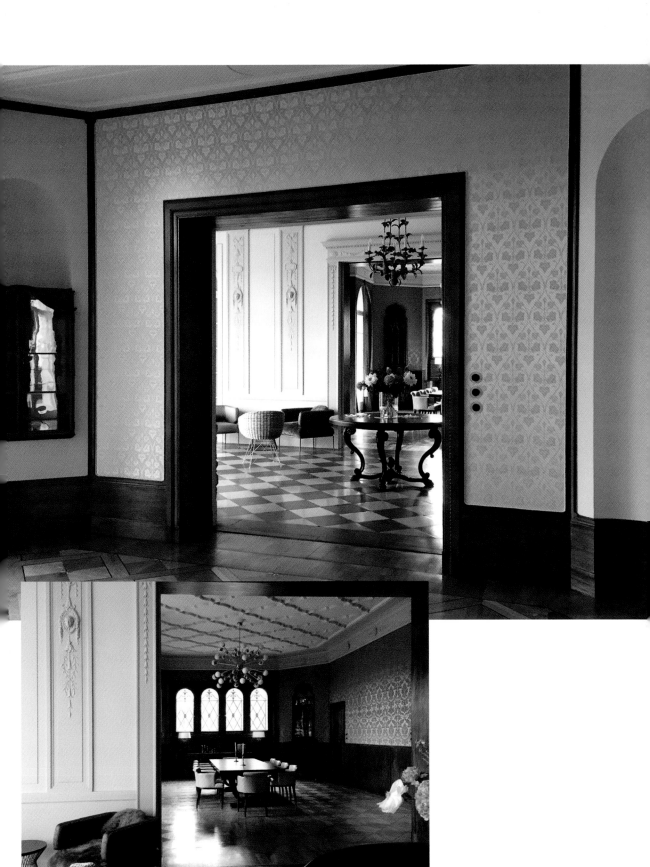

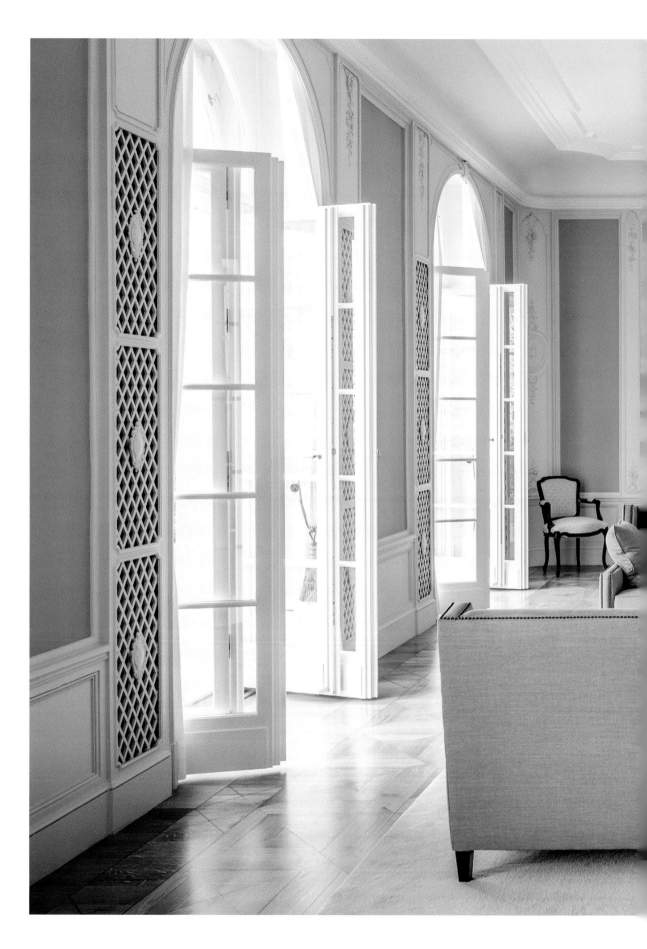

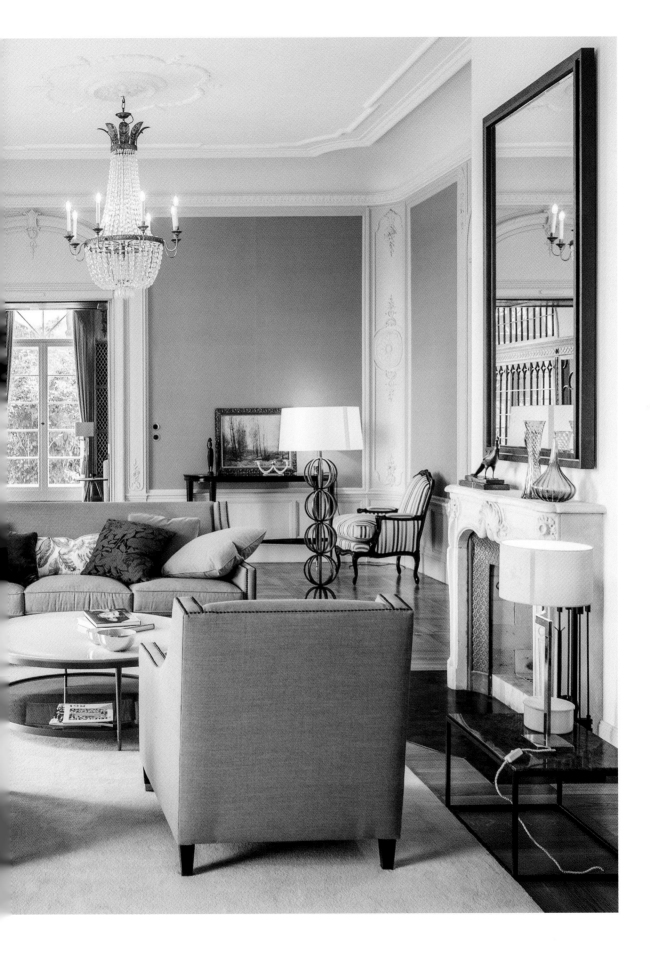

GROUND LEVEL

UPSTAIRS

Hall | Red Silk Splendour

Hallway | Serendipity

Library | Green Spades

Masterbedroom | Münster

Salon | Love in a Mist

Studio | Prim Beige

Music Room | Yellow Silk Sense

Living room | Spinnenseide

Garden Room | Hint of Mint

Child's room | Fibonacci

Dining Room | Mauve Must Have

Guest Room II | Elephant Imprint

Kitchen | Dunabar 76 + 78

Guest Room I | Oldenburg

Extra staircase | Flemish Blues 557

Gallery | Berry Freeze 1920

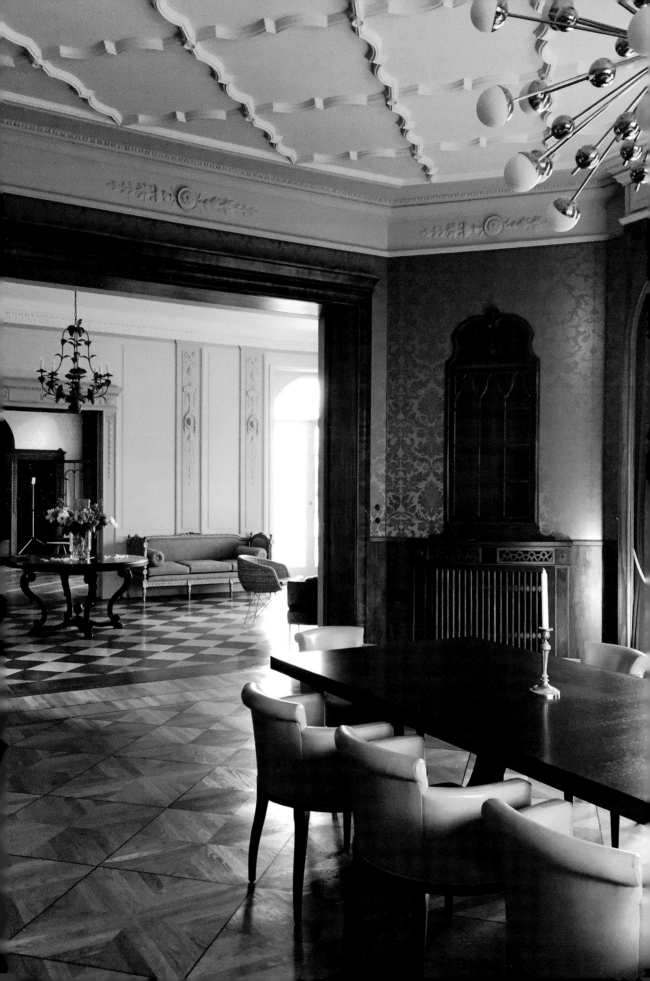

CAMPUS WESTEND II—INSTITUTE FÜR PSYCHOLOGY, AND EDUCATIONAL AND SOCIAL SCIENCES

NEW CONSTRUCTION | FRANKFURT 2012
FT: COLOR CONCEPT
CLIENT: MÜLLER REIMANN ARCHITECTS BERLIN

FRIEDERIKE TEBBE, born 1961, studied philosophy in Bonn and Munich, and painting at the Academy of Fine Arts in Munich. As a practicing artist her unique approach on the coherence of color and space, distinguishes her from many of her contemporaries. In her artwork she pursues this aspect through large color installation, murals, as well as in her photography. In 2001, she established Studio Farbarchiv, a color consultancy and interior design agency where she offers consulting for architects, designers and companies as well as private clients. In 2009, in collaboration with the artist Anette Haas, she won the competition for Architectural Art for the construction of the German Intelligent Service's new headquarters in Berlin. Together with numerous internationally renowned architectural bureaus, she has developed color concepts for buildings such as the Pushkin Museum in Moscow, the Helmut Newton Foundation and the Ministry of the Interior in Berlin. Her portfolio also includes such historically protected landmarks as the Berlin Philharmonic Hall and the Berlin Dom, the Kunstkammer in Wien and Villa Kampffmeyer in Potsdam, also part of the UNESCO World heritage site.

MATTHIAS HARDER, born 1965, works worldwide as a curator of exhibitions of contemporary art and photography. He has worked for the Museum of Photography / Helmut Newton Foundation since 2004. His articles and essays are published on a regular basis in international art magazines, books and catalogues.

Thanks to:

Maya Hässig, Anne Vonderstein, Magnus Neumeyer, Dean Moore, Matthias Harder, and Josephine Moore for their help, and support, and also to Jochen Visscher and Susanne Rösler from jovis for their competent advice and patience. I owe a debt of gratitude to the sponsors named below for their financial support.

Image Credits:

FRIEDERIKE TEBBE | cover + pages 4, 7, 8, 11, 12, 13, 14, 15, 16, 17, 18, 19, 20, 21, 23, 25, 26, 28, 30, 31, 33, 34, 36, 37, 38, 40, 41, 42, 45, 46, 49, 50, 52, 53, 55, 57, 59, 61, 63, 65, 66, 69, 70, 73, 74, 80, 82, 85, 87, 89, 90, 93, 94, 96, 97, 98, 101, 103, 105, 106, 109, 110, 111, 112, 113, 117, 118, 121, 129, 136 bottom, 138, 139, 140, 146, 148, 149, 153, 159
BRUNO KLOMFAR | pages 79, 128, 130, 131,
STEFAN MÜLLER | pages 22, 124, 136 oben, 137, 141, 142, 143, 144, 145, 154/155
MARKUS EBENER | pages 132, 133, 134,
16 ELEMENTS | pages 147, 150/151

Text Credits:

Page 43: https://www.vollebak.com/product/baker-miller-pink-hoodie/
(accessed 3rd November, 2016)
Page 44: Pastoureau, Michel: *Blau. Die Geschichte einer Farbe.* Berlin 2013, p. 9 |
http://www.jolie.de/leben/farben-bedeutung-8 (accessed 1st October, 2016)
Page 48: Minnaert, Marcel: *Licht und Farbe in der Natur.*
Basel/Berlin/Boston 1992, p. 151

Architecture Credits:

Pages 142–145: VON EY ARCHITEKTEN
Pages 140–141: MÜLLER REIMANN ARCHITEKTEN
Pages 146–153: KAHLFELDT ARCHITEKTEN

Note:

All names of colors come from the pool of studio farbarchiv and work as internal references.

With special thanks for their assistance to the following companies:

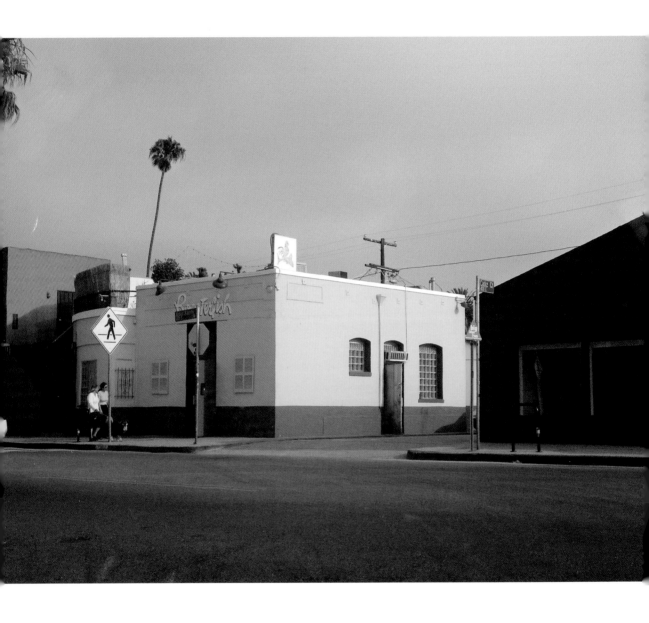

IMPRINT

© 2017 by jovis Verlag GmbH
Texts by kind permission of the authors.
Pictures by kind permission of the photographers/holders of the
picture rights.

Cover: Friederike Tebbe

Translation: Alison Kirkland, Ashford; Dean Moore
Design and setting: Friederike Tebbe; Susanne Rösler (jovis Verlag)
Lithography: Bild1Druck, Berlin
Printing and binding: DZS Grafik, d. o. o., Ljubljana

Bibliographic information published by the Deutsche Nationalbibliothek
The Deutsche Nationalbibliothek lists this publication in the Deutsche
Nationalbibliografie; detailed bibliographic data are available on the
Internet at http://dnb.d-nb.de

jovis Verlag GmbH
Kurfürstenstraße 15/16
10785 Berlin

www.jovis.de

jovis books are available worldwide in select bookstores. Please contact
your nearest bookseller or visit www.jovis.de for information concerning
your local distribution.

ISBN 978-3-86859-410-2